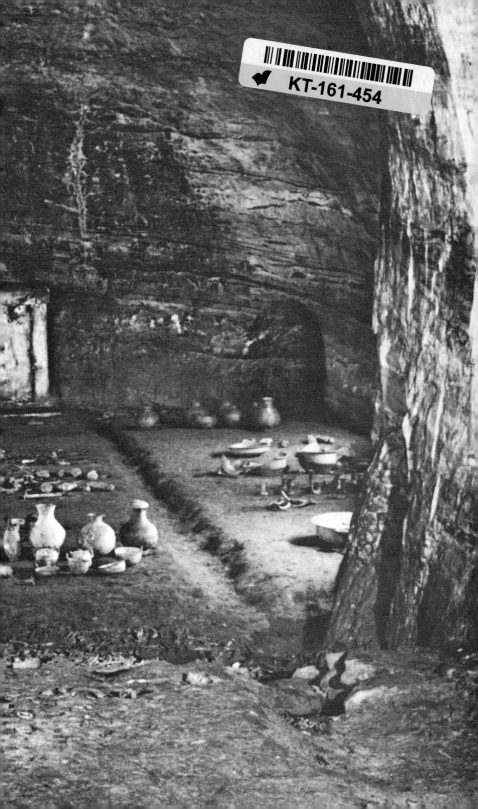

Treasures

MICHAEL RIDLEY

of China

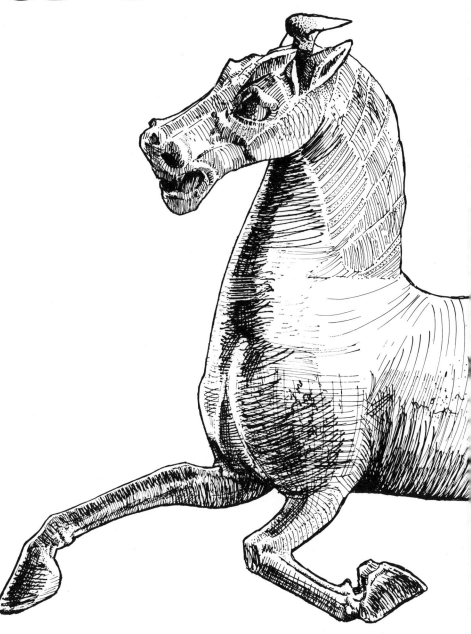

Cloth edition first published in Great Britain in 1973
by The Dolphin Press, 176 Barrack Road, Christchurch, Hampshire
ISBN 0 85642 040 9

Paperback edition first published in Great Britain in 1973
by Universal Tandem Publishing Co., 14 Gloucester Road, London.

ISBN 0 426 13135 5

First published 1973.

Copyright © Michael Ridley 1973.

Design – Duncan Webb & Associates

Printed in Great Britain by
Redwood Press Limited
Trowbridge, Wiltshire

CONTENTS

PUBLISHED IN
THE YEAR
OF THE
OX

INTRODUCTION

The chatter of excited voices slowly slurred until there was silence, a silence you could almost hear. The air was electric with anticipation. Suddenly there was a whoosh of cold air almost as if the past were making a hectic attempt to leave the place in a hurry, then an almighty bang. The crash and clang of the explosion as it blew off the iron door could be heard for some distance.

As soon as things settled down, the excited party made their way through the opening and into the darkness of the tomb. Then as the light from a lamp bathed the interior with a warm glow, the party gaped in wonderment as they saw the treasure that lay before them, buried some thousands of years before.

It was another in a series of archaeological discoveries; this time however what lay before them was not only to startle and delight those immediately involved, but people in many lands throughout the world.

One would be forgiven in assuming that this was a description of a major archaeological discovery in Egypt during the golden age of discovery, but one would be wrong. These dramatic events were taking place some thousands of miles away, in another age altogether. The country was China, the year 1968, during the Cultural Revolution and the discoverers – peasants, soldiers of the People's Liberation Army, and archaeologists.

Their discovery was of the utmost importance. Many Han tombs had been found and excavated before but this one of Prince Liu Sheng of Chungshan and that of his wife Tou Wan nearby, was to surpass anything that had been found before.

The massive tombs, carved out of the limestone hill

contained hundreds of treasures ranging from chariots, bronze vessels and lacquerware to the unique jade funerary suits worn by Prince Liu Sheng and his wife. The suits themselves were made from thousands of small jade pieces sewn together with gold thread. The contents of the tombs indicated a richness and opulence of culture, strange and even alien to the culture of those who had found it. The party chiefs were in a dilemma. Here was a find of great importance which ought to be publicised and yet one which in a way went against their political ideals. How were they to deal with such treasures. It was their heritage yet how could they justify such opulence. It was totally against their politics and there seemed no way round it.

The answer however proved to be simple, a typical compromise of the Chinese mind. Were not these treasures symbols of the cruelty and oppressiveness of the feudal ruling class and of the exploitation of the working people? Were not these discoveries clear evidence of the superiority of the working masses and of their skill and craftsmanship? Had not Chairman Mao said "The Landlord's culture is created by the peasants', for its sole source is the peasants sweat and blood".

With these major political problems solved, the news was published. It was also announced that many of the treasures discovered during the Cultural Revolution would be sent to the West as an Exhibition. This would not only show the world the progress made in modern China for preserving the people's culture but also exhibit the genius of the Chinese working masses.

The treasures of China have for long captured the imagination of people throughout the world. China has been looked upon as one of the fountains of civilis-

ation, a fountain from which sprang not only great philosophical ideas and scientific inventions but great masterpieces of art. It is with the latter that this book deals, though it cannot be divorced from either of the former which both influenced the artistic inspiration. The Chinese themselves have always been conscious of their past. Throughout history they have venerated their heritage and much of Chinese philosophy is based on ancestor worship.

The artistic achievements of ancient China were collected by early Chinese antiquarians, but for centuries that antiquarian interest was restricted to the collection of objects and to the criticism of the aesthetics involved, a purely peripheral interest. No attempt was made to verify facts or to separate fact from fiction. A great barrier was the tabu against disturbing the works of their ancestors. With increasing contact with the West this barrier was broken down, although the motive was not a search for knowledge but more for commercial gain. Thus, with the discoveries of T'ang tombs during the course of modern development and construction during the early part of this century, vast numbers of priceless treasures were exported from China for commercial gain. Many of these objects now occupy pride of place in museums throughout the world. Little excavation in the modern sense was carried out. Thus our knowledge of ancient China was for many years based on these objects in museums, often divorced from any information of their circumstance of discovery or excavation. The only other source was the published information from the relatively few excavations that were carried out or the Chinese written records which often failed to distinguish fact from mythology.

Excavations along more modern lines were carried out but they were very few indeed.

In recent years with a change of government in China referred to by the Chinese themselves as "liberation" and the establishment of the People's Republic, this state of affairs has begun to change. The Institute of Archaeology of the Chinese Academy of Sciences together with regional archaeological bureaux are doing valuable work. The atmosphere of co-operation brought about by the political climate of the new regime has caused the Chinese to work together with the archaeological teams reporting all finds promptly. This has resulted in vast new discoveries being made, which in earlier times may well have been neglected and not even reported.

From time immemorial Chinese craftsmen have produced wonderous works of art. The early Neolithic people who lived along the banks of the Yellow River have left us some of the most beautiful pottery of the ancient world. The fabulous painted pottery vessels from Pan Shan with their colourful curvilinear lines have caught the imagination of modern men. How did early Chinese man produce what is now regarded as the finest Neolithic pottery in the world? His successors in the Bronze Age were no less ingenious with their magnificent castings in bronze of ritual vessels. These vessels with their weird and wonderful relief designs and their lovely colourings of green and blue patinas are cherished today as some of the greatest masterpieces of all time. The skill employed by the early bronzesmiths in their castings still defies explanation. The jade work of the Bronze Age also survives to haunt the imagination. How did the early craftsmen carve with their primitive tools what is one of the hardest rocks known to man? What is

the significance of the many beautiful but peculiar shapes?

The genius of China did not end with the Bronze Age, however each succeeding period has left something to fascinate men over the centuries. The Han Dynasty (206 B.C. — A.D. 220) saw the first glazed pottery, while the succeeding T'ang Dynasty (A.D. 618 — 907) produced the first true porcelain, the forerunner of Ting ware. The T'ang Dynasty was also one of great artistic exhuberance which found its outlet in the tomb figures of the day.

These then are just a few of the many treasures of China which have survived to enliven the world of 20th century man. How has all this immense artistic wealth survived the course of centuries? How do we know what we know? The history of China and her art is full of questions, questions whose answers provide one of the most colourful stories of human achievement.

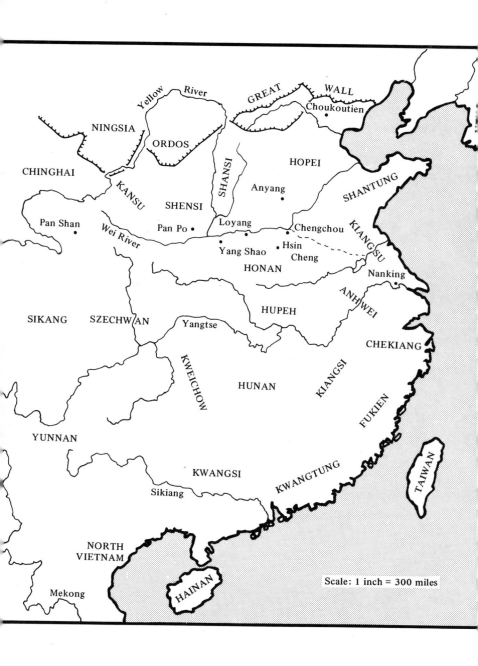

Map of China showing provinces and sites.

14

1 PAST AND PRESENT

Archaeology in China has in the past lagged far behind the rest of the world. While the remains of the great civilizations were being unearthed in the Mediterranean, Near East and India, China kept her secrets. Her ancient art however, was known and much admired, objects of great beauty and age adorned the show-cases of many a museum and private collection both in the West and East. The secrets of these objects lay buried in China's soil, for most had been collected by dealers and antiquarians who were mainly interested in the objects and not the culture of those who made them.

This was the general picture but not the whole picture. The antiquity of China's past had always been recognised. The ancient books and chronicles told stories of princes and kings, of kingdoms and empires and of battles and conquests. To most Chinese this was sufficient, everything was in order, everything was written down, their past was known. Chinese scholars of various periods in history had studied the texts, interpreted them and identified some of the relics with the texts. Scholars of the Sung dynasty greatly admired the ancient ritual bronze vessels of the Shang and Chou periods and made catalogues of them, trying to identify the forms with those described in the texts. Today, most of our terminology for these bronzes is

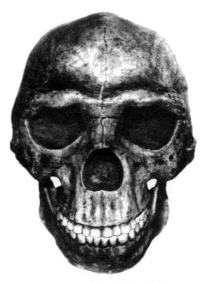

Reconstruction of the skull of Peking Man (c.500,000 years ago) fragments found in a cave at Choukoutien.

based on the interpretation of the Sung scholars, but excavation is helping to clarify things and some of these terms have been shown to be wrong.

Although many of the texts have been altered and interpreted in different ways over the years, they still provide a framework on which to base our knowledge of ancient China. The texts provide the skeleton and now archaeology, through excavations, is beginning to add the flesh.

Excavation in China is comparatively recent. Very few were carried out before the Second World War, those that did take place were sporadic and

15

much of the information obtained from them is unreliable. Indeed, recent work has shown the findings of some of these 'digs' to be incorrect.

Probably the most excavated site in China is Anyang in north eastern Honan. Here the first site of Bronze Age Shang civilization was discovered in 1899. Until 1927 the excavations there were clandestine, producing numerous bronzes which found their way onto the art market. In 1927 the first modern excavations were carried out. These continued until 1937 when they were interrupted by the Japanese invasion. Other sites were excavated but in a manner not compatible with modern techniques.

The situation then at the end of the Second World War, was that our knowledge of ancient China was still largely based on the traditional literary texts. Excavations at Anyang had thrown light on the complex Bronze Age civilization of the Shang dynasty. Chance discoveries of tombs of the Han and T'ang dynasties had produced vast numbers of beautiful works of art but little information which added to our knowledge of the period. Excavations at Choukoutien in

An archaeological excavation in modern China. Here soldiers of the People's Liberation Army are helping to excavate a Neolithic site.

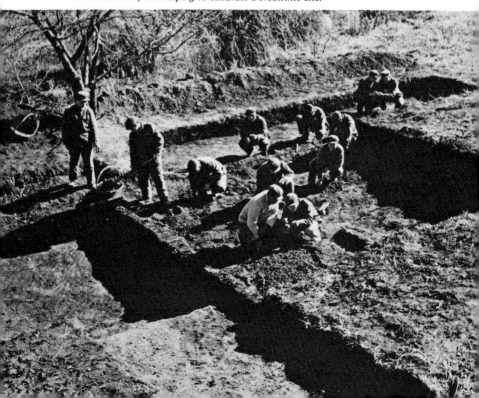

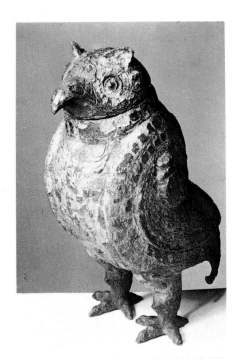

Large numbers of ritual bronze vessels continue to be unearthed in China today, especially in Shensi, Szechuan and Anhwei provinces. This *tsun*, ritual bronze vessel in the form of an owl, dates to the Chou dynasty. The term *tsun*, relates both to vessels in the shape of animals such as this and to a class of tall slender vessels.

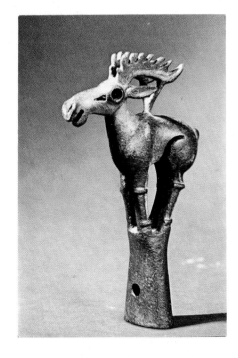

With the artistic influence of the Steppes came a tendency for increased naturalism. This bronze finial in the form of an elk from the Ordos region, dating to the Han period is easily distinguished from earlier bronzes which tend to be highly stylized.

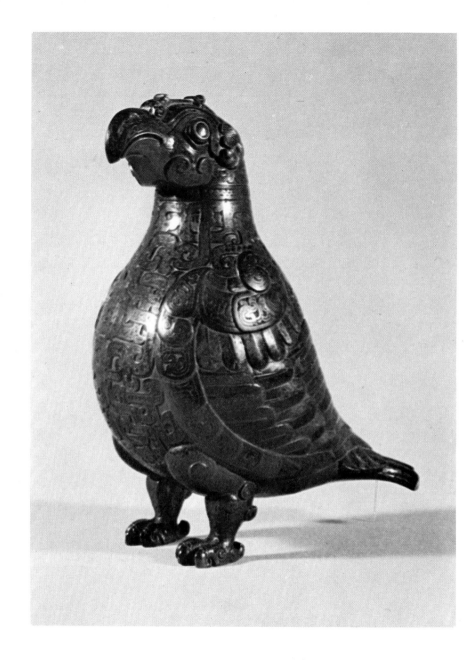

Ritual bronze vessels were made in a variety of forms, each one having a special function in the rites of ancestor worship. This beautiful bronze *Tsun* − ritual wine vessel in the form of a bird dates to the 10th century B.C.

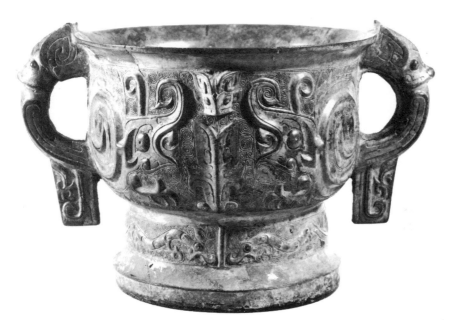

Ritual bronze food vessel, 'kuei', of the Shang dynasty (1523–1027 B.C.) excavated from Anyang.

1921 had produced the remains of China's earliest known inhabitant, Peking Man or Sinanthropus. Neolithic settlements were known on the banks of the Yellow River but little or nothing of the material remains of the 500,000 years or more between Peking Man and the Neolithic cultures. Other discoveries had been made by explorer-archaeologists like Sir Aurel Stein, who at the turn of the century discovered a vast cache of art treasures in the caves at Tun Huang on the western frontier of China. All these discoveries had been made by sporadic excavation or chance finds. At best, they could only illustrate the material culture of the ancient texts.

Since 1950 archaeology in China has progressed rapidly. Numerous sites of all periods have been found and excavated. The problem now seems to be that with so much activity, documentation and publication cannot keep pace. During the period 1950 – 1965 a number of important discoveries were made. The prehistory of China began to be unearthed with over 3,000 sites of the Palaeolithic and Neolithic periods being found, including further remains of Sinanthropus. Perhaps the most important

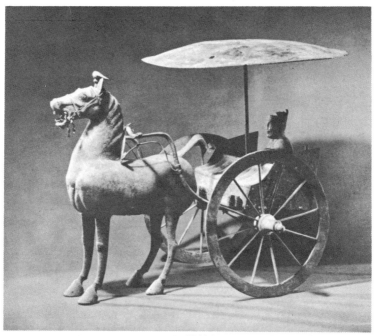

Bronze model of a chariot discovered in 1969 in a tomb at Leitai, Wuwei in Kansu. The chariot which dates to the Eastern Han dynasty (A.D. 25–220) was found with 76 other bronzes.

discoveries of the period were the finding of several complete chariots at Honan, early lacquerware at Changsha, in Hunan, and the amazing iron foundry of the kingdom of Yen, near Peking. Bronze Age sites which predated Anyang were also found.

With the internal upheaval of the Cultural Revolution came a revolution in Chinese archaeology; the professionals were joined by the masses. Although a frightening thought to any archaeologist in the West who is increasingly viewing archaeology more and more as a preserve of the professional, the Chinese seemed to have made the co-operation between people and professionals work, but only time will tell.

When the news of the Cultural Revolution broke in the West, much concern was expressed for the safety of China's cultural heritage. There were wild stories of Red Guards destroying priceless treasures. There may indeed have been a grain of truth in these

stories, but now as the veil of secrecy is raised we can see that archaeology, far from suffering under the Cultural Revolution, has been stimulated. We cannot as yet, however, judge whether we are witnessing a renaissance rather like that of the 19th century in Europe, when vast numbers of antiquities were unearthed but little history. Only complete publication of the results will satisfy the curious. The information that has been published, has however been astonishing and promises to greatly increase our knowledge of China's ancient past. The Cultural Revolution has meant that the professionals, soldiers of the People's Liberation Army and peasants have worked together and are responsible for all the recent spectacular discoveries.

Much of the archaeology is not being undertaken for purely archaeological reasons. Many of the discoveries are being made in the course of modern development, in the construction of roads, buildings, underground railways and major irrigation systems. In many cases the excavation is of an emergency nature.

Major political hurdles had to be overcome to rationalise the recovery and preservation of a bourgeois heritage with party

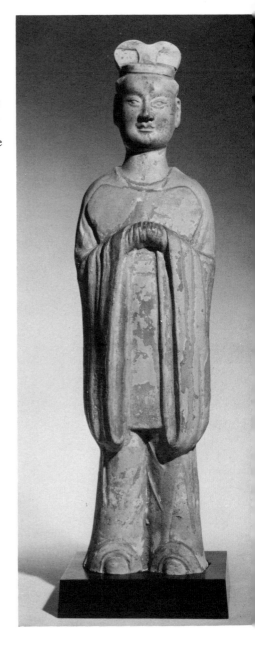

Pottery tomb figure of a man, T'ang dynasty, (AD 618–907).

21

Two glazed pottery figures of earth spirits unearthed from a T'ang tomb (AD 618–907).

politics. The party 'pundits' however soon had the answer, to them the finds illustrated the brilliance of the Chinese working masses and artisans, and showed their exploitation by the feudal overlords. Thus archaeology became a political tool. The seal of approval was applied with a saying of Chairman Mao "Another of our tasks is to study our historical heritage and use the Marxist method to sum it up

critically. Our national history goes back several thousand years and has its own characteristics and innumerable treasures".

The discoveries made during the Cultural Revolution have spanned the complete spectrum of Chinese history. The oldest find appears to be the 'daddy' of Peking Man. Now called Lantien Man after the find site at Lantien in Shensi province, the bones, a skull and maxillary bone predate

Peking Man. The remains of other early men, younger than Peking Man have also been found. Our knowledge of the Neolithic period has been greatly enlarged. Over 5,000 sites have been found and over 200 excavated. By far the most important of these was the excavation in Shensi, at Pan Po village, Sian. Here a large Neolithic village was uncovered revealing the sites of huts, kilns and a cemetery. Dating back nearly 6,000 years the site has preserved many wonderful objects.

China's most excavated site, Anyang, continued to be excavated as also were a number of other Bronze Age sites, including some belonging to an earlier phase than Anyang.

Without doubt the most spectacular discovery has been the tomb of Prince Liu Sheng and that of his wife Tou Wan. Liu Sheng was Prince Ching of Chungshan of the Western Han dynasty. The tombs were discovered in 1968 in cliffs at Mancheng, Hopei. Sealed by iron doors they contained over 2,800 fabulous objects including the unique funerary suits of Liu Sheng and Tou Wan made from numerous jade plates sewn together with gold thread.

In addition to these fine tombs, numerous other tombs of various periods have been discovered, each preserving some object or objects of great beauty. The tomb of Prince Chu Tan, Prince of Lu of the Ming dynasty was excavated in 1970 over a period of six months. The tomb proved to be a treasure house of Chinese art, preserving among other things, the Prince's robes, books, paintings, jewellery and other personal belongings. Over 300 volumes of books were recovered which in themselves promise to add to our knowledge of Chinese culture.

Excavations in Peking between 1965 and 1969 revealed part of Tatu, the capital of the Yuan dynasty. Part of the city wall, the barbican and a number of houses were discovered and a variety of beautiful antiquities recovered.

In a few short years the Chinese have tried to make up for years of stagnation. Thousands of objects from the recent excavations now await preservation, study and publication. The tangible results of the excavations are there for us to see and admire, it is now necessary to place them into the traditional framework of Chinese archaeology to produce a new, clear, and we hope more complete picture of Chinese art, culture and history.

2 BEGINNINGS

China hides many secrets in her soil. One of them may be the answer to the evolution of early man in the Far East. Peking Man was officially born on December 2nd 1927, when Dr. Davidson Black, a professor of Anatomy at Peking's Union Medical College, announced to the Geological Society of China that he had evidence for a new genus and species of man. He called him *Sinanthropus pekinensis.*

The story of the discovery of Peking Man almost deserves a place in an encyclopædia of detective stories, for that is what it is, a saga of scientific detection. The story begins at the turn of the century when a Dr. Haberer purchased a collection of "dragon's bones" in a Peking druggist's shop. Curious about them he sent them to Professor Max Schlosser at the University of Munich.

In 1903 Professor Schlosser published a long and detailed account of the fossil bones, identifying the series of species present in the collection. Pages twenty and twenty one proved to

Choukoutien near Peking, the home of Peking Man.

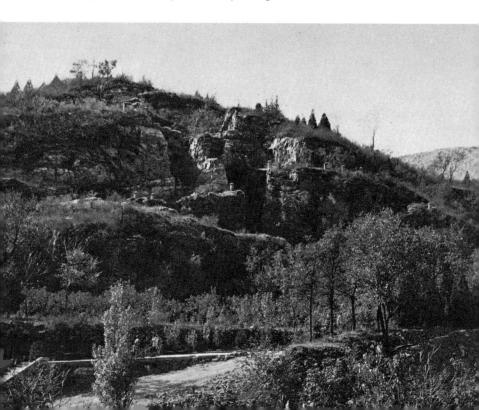

be what could be described in the scientific world as sensational reading. Professor Schlosser had set down the results of his examination of a left upper premolar "either of a man or hitherto unknown anthropoid ape". His painstaking examination of the tooth revealed a number of interesting points, which after comparison with other remains, led him to the conclusion that it could have come from a human being closer to ape than man and older than any type of man known at that time. This was amazing for he arrived at this conclusion on the evidence of the tooth alone, without any information about provenance or the circumstances of discovery before him.

There the matter rested until 1921. Professor Gunnar Andersson, a Swedish geologist, working for the Geological Survey of China, found amongst fossil bones in a cave at Choukoutien, near Peking, evidence of the presence of primitive man. His evidence, however, was extremely slender, a piece of quartz geologically foreign to the cave. In 1922, with funds obtained in Sweden, excavations were carried out by Dr. Zdansky and the finds sent to Uppsala for examination. It was not until 1926, during the visit of the Crown Prince of Sweden to Peking, that it was announced that the excavation had revealed two human teeth. Dr. Zdansky was not greatly

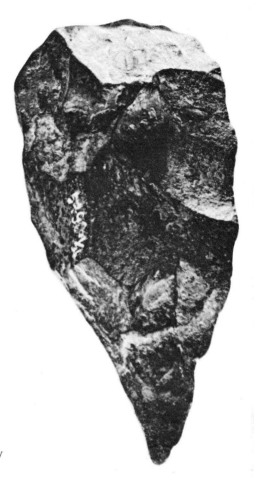

Stone hand-axe used by Tingtsun Man of the Middle Palaeolithic period. The tool was excavated along with others at at Tingtsun, Hsiangfen, Shansi.

impressed with them and did not think them of major importance.

Professor Davidson Black, on the other hand had other views. Since 1915 he had worked on the idea that remains of early man would be found in China. To him this was the clue, the pointer. At his instigation and with financial help from the Rockefeller

Foundation, another excavation was undertaken. On the 16th October 1927 Dr. Birger Bohlin found another tooth at the same site as Dr. Zdansky.

Dr. Davidson Black argued that the morphology and proportions of both the Bohlin and Zdansky teeth indicated that they were human and generally distinct from all other known human types. His creation of a new genus did not meet with general approval and it was not until a year later with the discovery of two jaws and braincases, that some of his critics were silenced.

At the time stone tools could not be associated with Peking Man, but since then, a series of flake tools have definitely been able to be associated with him.

After Black's excavation, work continued at Choukoutien until the Japanese invasion. Since 1950 excavation has recommenced at the site and further bones found. Altogether, the remains of over forty individuals have been discovered.

The whole area of Choukoutien was divided up into sections, for ease of identification. What appears to be one of the earliest deposits, section 13,

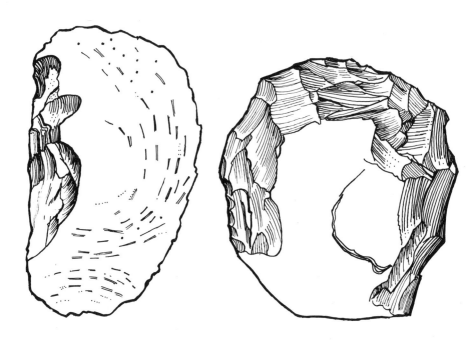

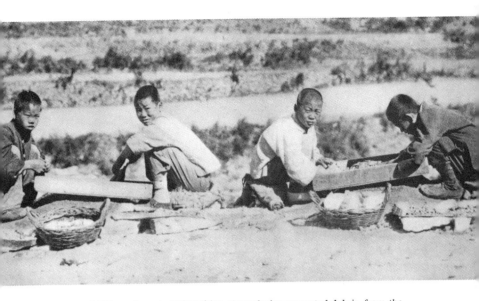

A group of Chinese boys in 1927 sifting through the excavated debris from the caves at Choukoutien in search of stone tools of Peking Man.

Stone tools of greenstone, quartz, and chert made by Peking Man some 300,000 to 500,000 years ago. A number of different types of tools were found at Choukoutien including chopping tools, flakes used as scrapers and knives.

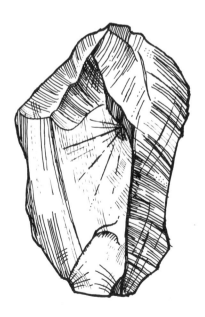

27

produced what could be the earliest human artifact found in Asia, a small chipped pebble, about 7.5 cm. long. A deposit over 150 feet deep at section 1, produced numerous tools and human bones. This association of one with the other is most valuable and leaves no doubt about their association. The tools were mainly chopping tools or flakes, used as knives or scrapers, made of greenstone or quartz, sandstone or chert. Another site, section 15, produced more advanced tools, made with improved techniques. These are comparable with those found recently with the remains of Tingtsun Man, at Tingtsun in Shansi. Tingtsun was a slightly more advanced "model" of Peking Man, but probably not that much different to look at.

Peking Man is thought to have lived during the Pleistocene times, about 300,000 to 500,000 years ago. He was upright, but his skull had a rather heavy brow and his brain size was about two-thirds that of modern man. He was a hunter. Probably the most startling fact that has emerged from recent excavations is that Peking Man knew the use of fire. Deposits of ash suggest that he built fires at the mouth of his cave, which would not only provide warmth but also act as protection from wild animals. Another startling but macabre fact is that he was probably a cannibal. The large number of

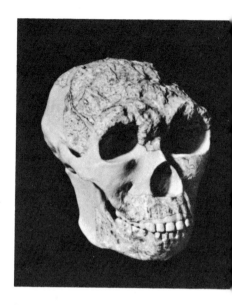

Reconstruction of the skull of Lantien Man from fragments unearthed in 1963 and 1964 at Lantien, Shansi.

skulls that had been broken open suggests that he had a liking for human brain.

When he was first discovered, Peking Man was thought to have been a separate species of the human family. Recently, comparative studies of Sinanthropus and Java Man have suggested that they are both members of the species *Homo erectus*, thus Peking Man has lost his former position on the human tree of evolution.

Every year further excavations reveal more remains of China's primaeval inhabitants. The most

recent discovery was the remains of *Sinanthropus lantienisis*, Lantien Man, an ancestor of Peking Man. He is named after the find site Lantien in Shensi province where fragments of a skull and lower maxillary were found.

Peking Man belongs to the Lower Palaeolithic period, a

Above: *Peking Man's quartz flake tools, from Choukoutien.*

Site of the 1927 excavations at Choukoutien near Peking.

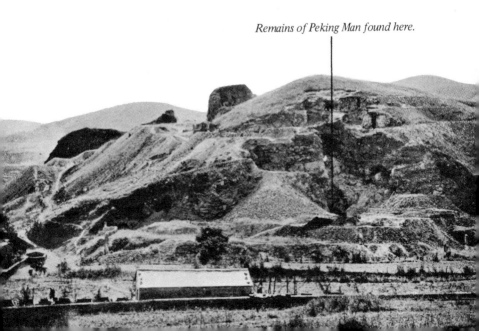

Remains of Peking Man found here.

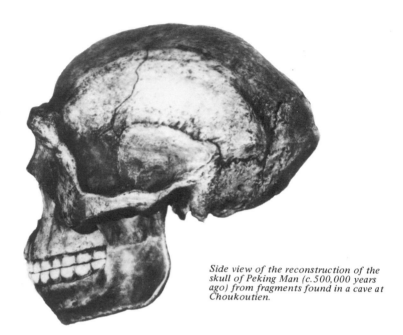

Side view of the reconstruction of the skull of Peking Man (c.500,000 years ago) from fragments found in a cave at Choukoutien.

period which extends for several hundred thousand years.

Although the remains of Peking Man have survived in reasonable abundance, with the exception of Tingtsun Man and Tzuyang Man, the remains of his successors have not. On the other hand, recent excavations have unearthed numbers of his artifacts, providing important evidence for us to piece together a picture of this remote period of Chinese prehistory.

While Lantien Man was the beginning of man in China, it was the Neolithic period that was the beginning of civilized culture.

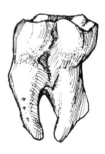

Top: *Tooth of Peking Man used by Dr Davidson Black to establish the genus Sinathropus pekinensis.*

Peking Man

3 NEOLITHIC REVOLUTION

Since 1950 over 5,000 Neolithic sites have been discovered and over 200 excavated, but even with all this activity we are only just beginning to understand the complex situation of China's Neolithic Revolution.

Our knowledge of the long period of time between Peking Man of the Lower Palaeolithic and the appearance of the Neolithic culture, is even hazier. Much work will have to be carried out before we can arrive at the detailed picture that we have for this period of time in Europe and Africa. Things are being done about this gap and already a number of sites and artifacts have been found.

We now know that as elsewhere, the Palaeolithic tradition of hunting gave way to the Mesolithic practice of food gathering and hunting. This appears to have taken place much earlier than elsewhere and continued even after Neolithic farming communities had been established. This is probably due to the geographical location of the communities. In some areas, especially the fertile river valleys, agriculture was comparatively easy, while in other areas, it was almost impossible.

We do not know exactly when polished stone tools characteristic of the Neolithic period began to be made, but it is possible that some were being made in the period that we classify as Mesolithic.

The Neolithic period (c.3800–1800 BC) is marked by a change in the economy of people, a change in their way of life, a change from food gathering and hunting to food producing — agriculture. It is for this reason that we sometimes refer to the change-over as the Neolithic Revolution. It was not a

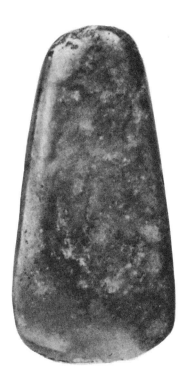

Neolithic polished axe from Hsinhsien, Honan.

Neolithic painted pottery jar excavated from Pan Shan, Kansu.

revolution in the modern sense, but a slow revolution of the mind and habits of man, spread over a wide period of time. It heralded the foundation of civilization itself.

Through recent excavations we now know that there were a number of Neolithic cultures, some were contemporary and co-existed with each other, while others developed later. They include amongst others, the Yang Shao and Lung Shan cultures. The former is characterised by a red painted pottery and the latter by a thin walled black pottery. The Yang Shao culture is named after the village of Yang Shao in Honan when it was first discovered and the Lung Shan after the village in Shantung. A third culture, related to the Yang Shao, has been found in Kansu province. There has been much discussion and controversy as to which of these cultures developed first and what their relationship was to each other. Recent excavations have helped to clarify the picture, though events are by no means clear.

Basically, there are three main regional traditions and two main cultures. The Kansu tradition is related to the Yang Shao culture, while the Lung Shan is a separate culture on its own. Geographically the Yang Shao culture sites have been found in Honan, Hopei, Shensi and Shansi, and even in eastern Kansu on the banks of the Wei River, Kansu, as its name suggests is restricted mainly to Kansu. The Lung Shan culture is indigenous to east and north east China, though its sites have also been found on the central plain.

The difference between the two major traditions of Neolithic culture, the Yang Shao and the Lung Shan has been suggested to be the developed cultures of itinerant farmers on the one hand, and on the other, a settled village community. There is, however, little evidence to support this.

Excavations since the establishment of the People's Republic of China, have unearthed a number of sites of the Yang Shao culture, but the most important must be at Pan Po

Chinese Neolithic pottery is probably the finest neolithic pottery in the world. The superb sense of design and form can be seen in this fine pottery jar of the Kansu tradition from Pan Shan.

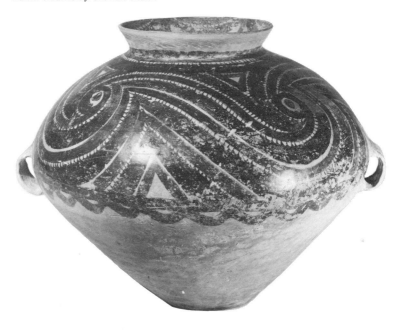

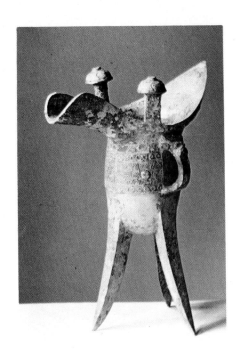

During the Cultural Revolution, excavations at Yin Hsu (Anyang, Honan) capital of the late Shang dynasty have unearthed a number of ritual bronzes which may increase our knowledge of these beautiful and unusual vessels. This Shang vessel is known as *Chueh* — a ritual libation cup.

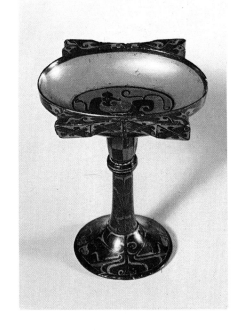

There is evidence to show that lacquer was in use during the Chou period. Recent excavations have revealed the crumbled remains of wooden objects with traces of lacquer but complete objects such as this winged pedestal cup attributed to the late Chou period, 5th — 4th century B.C., are rarely found.

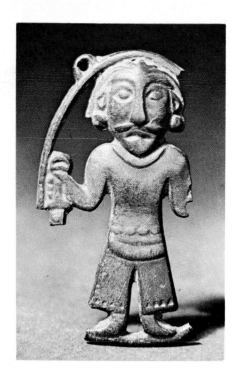

Many unusual bronze figures and ornaments have been recovered from the Ordos region. During the Han dynasty, the nomad art of the Steppes had a profound influence on the bronze work, clearly seen in this figure of a man which dates to that period.

Although there is evidence to suggest that lacquer was in use during the Chou dynasty and even earlier, the earliest lacquerware which has survived dates from the 'Warring States' period. Excavations of tombs at Ch'ang Sha in Hunan have produced a number of beautiful objects including this lacquer sculpture of Cranes and Serpents dating to the late 'Warring States' period.

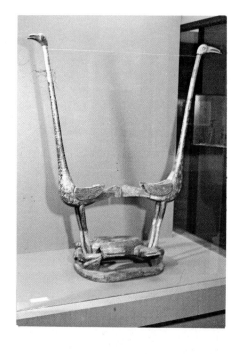

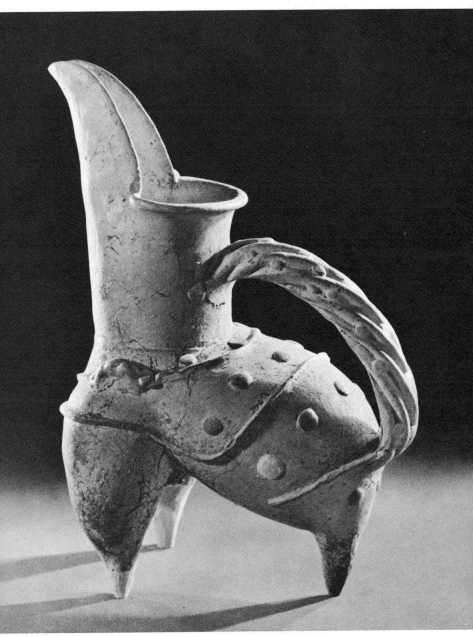

An unusual Lung Shan pottery water jug, "kuei", excavated from Weifang. Shantung.

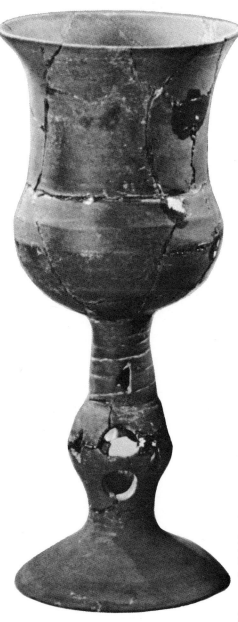

village in southern Shensi. Part of this site has been preserved and roofed over. The excavation has given us a vivid picture of life in Neolithic China. Villages were circular and undefended. The houses were also circular with a central pillar supporting a thatched roof. Features such as cupboards, stools and ovens were constructed of clay and sometimes the floors were dressed with white clay. The villagers grew millet (there is slight evidence of rice cultivation) and kept pigs (the bones of goats and cattle have been found in the north-west). Grain was stored in pits and their tools were of chipped stone both polished and unpolished.

It is the pottery of the Yang Shao culture that is so distinctive and remarkable. It is hand made without the use of a potter's wheel. The red clay which was fired at temperatures of $1000°$ – $1400°$C., was painted while still drying before firing. The most common forms are jars and deep bowls and the designs are geometric in red or black. A coarse ware was also made which was decorated with incised designs, combing or impressed matting. While the fine ware of the Yang Shao culture is outstanding as Neolithic pottery, it is the Kansu tradition of the Yang Shao that claims the accolade. The most

Neolithic, Lung Shan black pottery stem-cup excavated at Anchiu, Shantung.

38

important site of the Kansu tradition is Pan Shan where hundreds of beautiful painted jars were uncovered from a cemetery.

The painted pottery of Kansu is probably the finest Neolithic pottery in the world. The upper half of the urns are painted with spirals, abstract and geometric motifs, in black, red and purple. A device often found on funerary urns is a fringe of small dog tooth lines, which has been called the "death pattern".

It has been suggested that Kansu pottery was directly inspired from sites in the west outside China, in Turkestan, the Ukraine, the Caucasus, and the Balkans. It has also been suggested that the influence was from the Yang Shao culture in the east, but recent excavations suggest other possibilities. Chinese archaeologists now believe that Kansu was a later development of the Yang Shao. This is based on evidence from sites at Ma Pao Chuan in Tienshui, and Szeping in Wei Yuan, where the Kansu Ch'ichia culture was stratified above Yang Shao. Excavations at Huangniangniangtai, Wuwei, have shown the Ch'ichia culture to be later than the Kansu Ma Chia

View of part of the excavation of the Neolithic village at Pan Po, Sian southern Shensi, the most important site of the Yang Shao culture yet discovered.

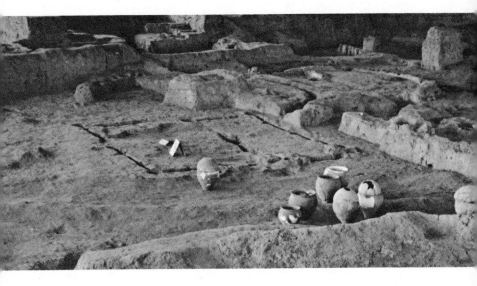

39

culture, but contemporary with the Lung Shan culture of the Yellow River valley. The Ma Chia culture itself is later than the Yang Shao. This is all very complicated, but then the Neolithic picture of China is very complicated.

The third Neolithic culture, the Lung Shan is a northern tradition. It is named after its find site Lung Shan (Dragon Mountain) at Cheng Tsu Yai, western Shantung. Its pottery is black and unpainted and is of different forms to the Yang Shao and Kansu pottery,

Neolithic painted pottery jar of the Kansu culture excavated from Tienshui, Kansu.

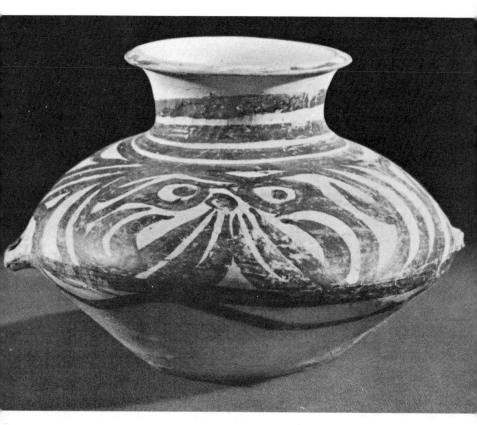

being made on a wheel. Some of the shapes, the Li, the Ting, the Chia and the Hsien, continued into the Bronze Age Shang period, when they were made in bronze. The fine black ware was the finest and the rarest, more common is the coarse ware of grey, red, black and sometimes white.

Apart from the differences of pottery form and fabric, there are other differences between the Yang Shao and Lung Shan cultures. Unlike the Yang Shao, Lung Shan villages are defended by a wall of stamped earth. The stone tools also differ, though burial rites appear similar. Divination by oracle bones in the same manner common in the Shang dynasty was also carried out.

The exact relationship between the Lung Shan and the Yang Shao cultures remains something of a mystery. What seems fairly certain, however, is that the traditions of the Lung Shan culture continued into Bronze Age times to influence and probably form the nucleus of the traditions of the Shang dynasty. A number of practices were common to both, including some shapes first made in pottery during the Lung Shan period, later developed in bronze during the Shang dynasty; divination by oracle bones and the practice of building with packed clay.

There is a short intermediate culture called the Hsiao-T'un culture, between the Lung Shan and the beginning of the Shang dynasty. This culture is more closely allied to the Bronze Age than the Neolithic. Its pottery is a fine grey ware with cord or matting patterns on the surface.

The dates of these Neolithic cultures are somewhat vague and are likely to remain so until more radio carbon dates are available.

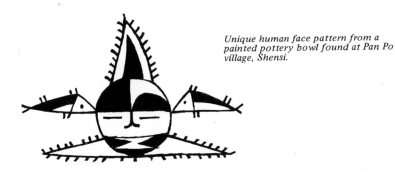

Unique human face pattern from a painted pottery bowl found at Pan Po village, Shensi.

4 ROYAL TOMBS OF SHANG

The Shang dynasty (traditionally 1523 – 1027 B.C.) was founded on the practice of bronze casting and it is the products of this Bronze Age technology, the ritual vessels, which today act as symbols for the whole period. Archaic ritual bronzes have been venerated in China for centuries. Chinese antiquarians treasured them and Chinese scholars studied them. As early as the Sung dynasty (A.D. 960 – A.D. 1280) collections had been made and in keeping with the keen interest in antiquity prevalent at the time, catalogues compiled. They studied early ritual texts which described the vessels and their uses and tried to identify bronzes in existence with the descriptions. These were

courageous attempts as they only had the bronzes and the texts to work on, they did not have the benefit of the results of excavations that we have today. Even so their work proved remarkably accurate and the names we use for the bronzes today are largely based on the results of this scholarship. As one would expect, excavations have shown some to be wrong, but there have been few changes.

Most of the superb bronze vessels of the Shang and Chou dynasties (c.1523 – 475 B.C.) that we are familiar with today have come from tombs. They were cast to commemorate certain rituals and sacrifices and as funerary furniture, buried with

An unusual bronze ritual wine vessel. "Kuang", dating to the Shang dynasty (1523–1027 B.C.), excavated from Shihlou, Shansi.

royalty and nobility. Rituals during this period required offerings of food and drink, while sacrifices, both human and animal, were made especially at funeral rites.

The technology and workmanship apparent in these vessels is amazing. For years modern scholars could not understand how such advanced bronze casting suddenly appeared virtually out of the blue. This led to the theory that bronze casting had been introduced into China fully developed. But from where? Recent excavations have shown this to be wrong. They have unearthed prototypes of the majestic vessels of the Shang and Chou dynasties. These early vessels are thin and the decoration rudimentary. It seems, then, that bronze casting was developed by the Chinese themselves.

Many of the Shang and Chou bronzes are covered in beautiful patinas of blue and green, the result of being buried for centuries in the earth. The surface of the bronzes are mostly decorated in relief with highly stylised motifs of dragons, animals, masks and geometric designs. Scholars are not always in general agreement about the method by which these bronzes

were made, and it is possible that more than one method was used. The majority, however, appear to have been cast by the cire perdue or lost wax process. This process required an original to be modelled in wax, which would then be moulded and cast in bronze.

First the shape of the interior of the vessel would be modelled in clay mixed with husks and other ingredients. On to this shape the design of the vessel would be moulded or carved in wax. The wax matrix thus formed would then be covered with a layer of fine clay so that all the design on the surface of the wax original was covered. Care had to be taken to ensure that bubbles were not

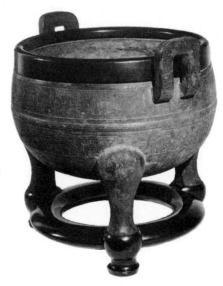

Chinese antiquarians collected ritual bronzes, often mounting them on wooden stands, like this "Ting".

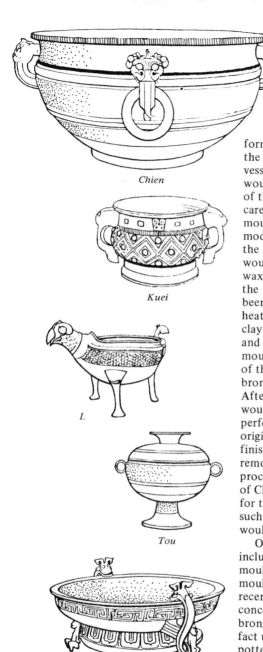

Chien

Kuei

I.

Tou

P'an

Some of the shapes of ritual bronze vessels in use during the Shang and Chou dynasties.

formed as they would show on the surface of the finished bronze vessel. The thin clay covering would then be covered with layers of thick clay. Stays would then be carefully inserted into the outer mould until they pierced the wax model and the core, holding all the components in place. Holes would then be made to allow the wax to escape and later to admit the molten bronze. This having been done, the mould would be heated in a hot oven, so that the clay hardened and the wax melted and escaped. This would leave a mould with a perfect impression of the wax original. Molten bronze would then be poured in. After it had cooled, the mould would be broken open to reveal a perfect bronze copy of the wax original. The bronze would be finished by the smith who would remove all traces of the casting process. The early bronze workers of China were extremely clever, for they arranged the stays etc., in such a way that the marks, if any, would merge with the design.

Other methods were employed, including the use of pottery moulds. Several fragments of these moulds have come to light in recent excavations, some concealing minute pieces of bronze, proving that they were in fact used for casting. These pottery moulds were made in several sections with key grooves. When assembled, an inner core would be suspended from the top and the molten bronze poured

in. When cool the mould could be dismantled to extract the bronze vessel. It has been suggested that the pottery moulds were used to make the wax originals for casting by the cire perdue process. This would certainly have been possible and it might well have been that both methods were used. Modern technologists, however, are of the opinion that some of the more intricate bronzes could only have been cast by the cire perdue process. It is a sobering thought and a reflection on our society, when we realise that these vessels were made some three thousand years ago. Even today with all our modern technology there would be few people, if anyone, capable

The earliest glazed pottery vessel yet found. This yellow glazed pottery wine vessel, "Tsun", dating to the Shang dynasty was unearthed at Chengchou, Honan.

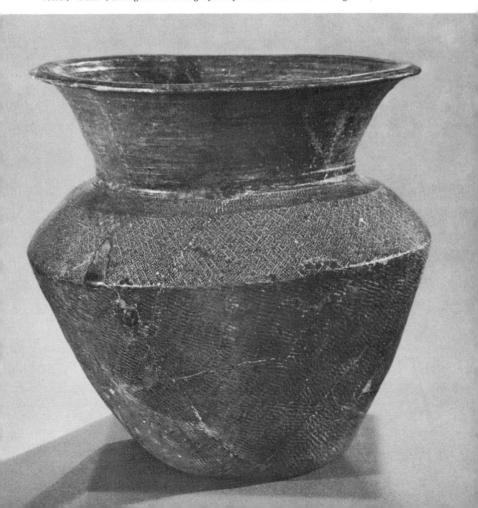

of producing vessels of the quality of these early bronzes, the technology of which had been entirely evolved indigenously.

The motivation for the manufacture of these vessels was magico-religious. They played an important part in the rituals associated with religion and statesmanship. Each vessel had its own name and function. The names by which we know the vessels today are those listed by the Chinese academics of the Sung period (AD 960 – AD 1280). Although some have been proved by inscriptions on vessels, others are at variance. Apart from straight forward mistakes, it is possible that the descriptions of the vessels were not as rigid as we might suppose.

Ritual vessels can roughly be divided into containers for a) cooked food; b) preparing sacrificial food; c) wine; d) warming black millet wine; e) drinking wine; f) water.

The first group, food vessels, consisted of the *Kuei* and the *Tou* both food containers, and the *Li, Ting* and *Hsien,* which were

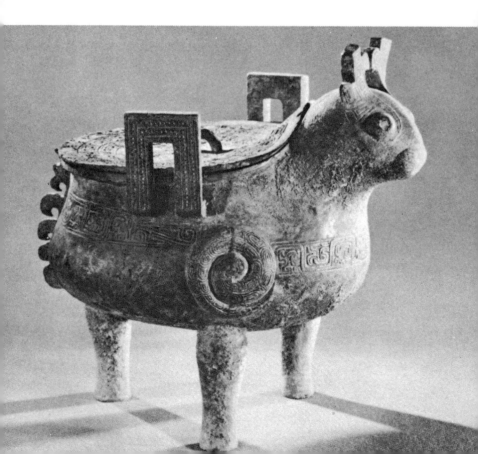

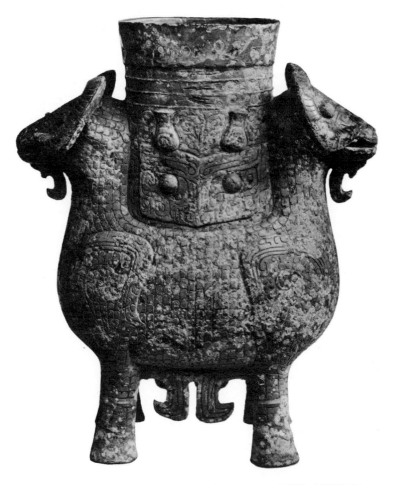

Bronze ritual wine vessel, "Tsun", Shang dynasty (1523–1027 B.C.).

Left:
Bronze ritual food vessel, "Ting", in the form of an animal, unearthed at Shucheng, Anhwei. Ritual wine vessels were made from the Shang dynasty to the Spring and Autumn Period, the late Chou dynasty. This one dates to 770–475 B.C.

cooking vessels. The *Kuei* were developed from pottery prototypes of the Neolithic Yang Shao culture. It is basically a high sided bowl with handles on a ring foot. The *Tou*, a pedestal bowl, with cover also appears to have developed from prehistoric prototypes. Of the cooking vessels, the *Li* and *Ting* are very similar. The *Li*, developed from prehistoric prototypes is a tripod vessel which has the lower part of the globular body divided into three lobes which act as legs. The *Ting* is also a tripod cauldron but has solid legs. There is also a four-legged model. The *Hsien* is a composite tripod "steamer" cauldron, basically a *Li* to which has been added a bowl. There is usually a rigid grille between the upper and lower halves.

The second group, wine vessels, consists of wine containers, for heating and mixing wine, and goblets and drinking vessels. The *Tsun*, *Yu* and *Hu* are wine containers, the *Ho* and *Kuang* wine heaters and mixers, and the *Chih*, *Ku*, *Chia* and *Chueh* wine goblets and drinking vessels. There is not general agreement as to what form the *Tsun* applies. However, for our purposes we can say that it may describe two types of vessel, a tall slender vessel, related to prehistoric pots of similar shape, and vessels in the form of animals. The *Yu* is a bucket like vessel with lid and swinging handle. The *Hu* is a large bulbous vase like vessel with a lid,

An oracle bone inscribed in archaic characters. The cracks produced by heating these bones would be interpreted by the oracle for his client.

and is one of the largest types of ritual bronzes. The *Ho* is similar to the *Li/Ting*, but as it was used for mixing wine with water, it has a spout, handle and lid rather like a teapot. The *Kuang* on the other hand is like a sauceboat with a lid. The shapes of the drinking vessels were various. The *Chih* is similar to the *Hu*, but smaller and without handles. The *Ku*, a tall cylindrical vessel with a flaring trumpet like mouth, was only produced during the first phase, about the 13th — 10th century B.C. The *Chia*, an archaic type of tripod vessel was not produced

after the 10th century B.C. It is characterised by an inverted almost bell shaped body, with splayed legs which taper to a point. Two capped pillars rise from the bell mouth and there is a handle which virtually spans the bell body. There is another drinking vessel, the *Chueh* which is similar shape to the *Chih* but which has a large boat shaped mouth.

In addition to the above, there is a group of water vessels which include the *I*, the *P'an* and the *Chien*. The *I* seems to be an evolved form of the *Kuang*. The

Chou dynasty (1027–770 B.C.) ritual bronze water pot, "Ho", with a lid in the form of a bird. Excavated from Meihsien, Shensi.

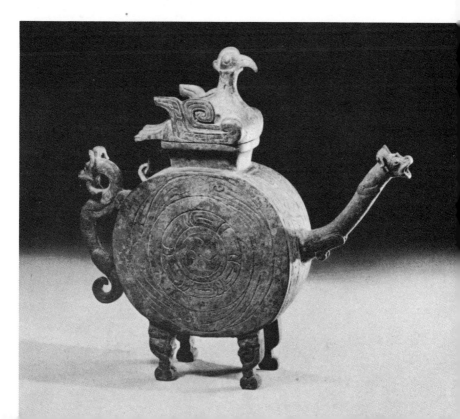

P'an is a shallow, circular, sometimes oval bowl resting on short legs. The use of the *Chien* is uncertain. It is a long, deep, basin like bowl, usually with a lug or vertical loop handles. It has been suggested that they were filled with liquid and used as mirrors, but early texts suggest that they were filled with ice and may have been used to prevent a corpse from putrifying before burial.

The production of bronzes falls into several distinct phases, during which various shapes and motifs came in or out of fashion. During the Shang period the decoration of bronze vessels was dynamic and vibrant, with deep relief designs. During the succeeding Chou period, the designs became more subdued and the relief decoration shallower.

Decorative motifs varied from time to time, but mainly consisted of either purly geometric designs (probably inspired from animal forms) and designs of animals, birds or parts of animals. Those of animals are highly stylised geometrically, and it is often difficult to discern exactly what animal is being portrayed. The most popular and important forms were the *t'ao-t'ieh*, masks of dragons and animal heads of which there were a number of forms. Creatures with large eyes, such as snakes, owls and cicadas were popular.

There are numerous versions of the *t'ao-t'ieh* mask. Basically, it is a stylised geometric mask produced by the merging of two animals in profile, face to face, the two merging to form a mask. It is almost as if the animal has been split down the middle and opened up flat. The various parts such as legs, tail, snout, jaws, fang

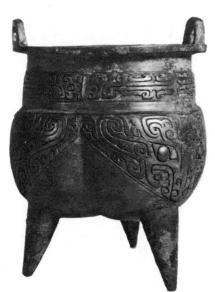

Left: *"Ting", ritual bronze cauldron. Shang dynasty (1523–1027 B.C.).*

Right: *"Kuang", ritual bronze wine vessel in the form of a mythical animal. Western Chou dynasty (1027–770 B.C.) found at Fufeng, Shensi.*

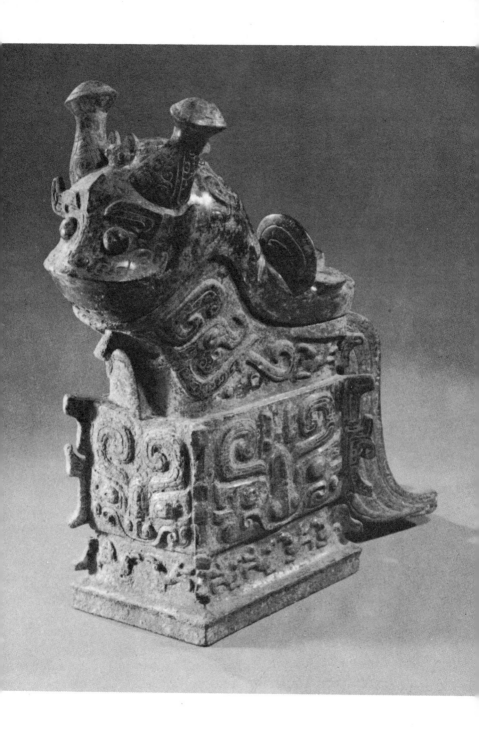

or beak, eyes etc. then form a highly stylised face. The so-called dragon motifs, the *kuei*, are like the unsplit side section of the *t'ao-t'ieh*.

In 1899 the first site of Bronze Age Shang civilization was discovered at Anyang in north east Honan. Here sporadic and unofficial excavations were carried out until 1929, the finds of bronze vessels and oracle bones finding their way on to the open art and antiquity market, and from there into museums throughout the world.

It was not until 1927 that excavations were carried out along more modern lines. These continued until 1937 when work had to stop because of war with Japan. Excavations re-opened in 1950 after the establishment of the People's Republic of China and continued throughout the Cultural Revolution. These recent excavations are extremely valuable to us as bronzes and other artifacts unearthed have been able to be associated with stratigraphy and each other, something almost impossible before. The travelling exhibition of archaeological treasures of China sent out by the Chinese Government in 1973 has provided the first opportunity not only to see many unique antiquities, but also objects which have been unearthed in modern excavations, and therefore are accompanied by information gained at the time of discovery in the soil.

The excavations at Anyang were greatly hampered by the effects of the early treasure hunters. Excavation of sites at Hsiao T'un, Hou Chia Chuang and Wu Kuan have given us a much clearer idea of Shang China. Some of the most dramatic discoveries of early excavations were made at Hsiao T'un between 1927 and 1936. Here, archaeologists found evidence of the barbaric rites of human sacrifice carried out during the Shang period. Associated with the remains of buildings were numerous burials of sacrificial victims. It appears that special rites which involved human sacrifice were held before the erection of certain structures. Groups of men, some with bronze vessels in their hands, others with halberds, were buried outside the gates. Human sacrificial victims were also buried at intervals

The "Pi", a ritual jade disc symbolising heaven. Chou dynasty.

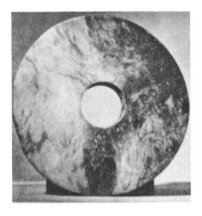

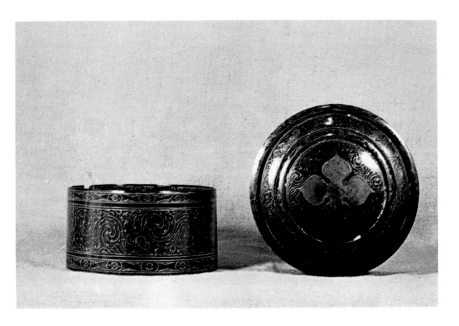

During the Han dynasty, the manufacture of lacquer objects was under the direct patronage of the Emperor. Three workshops are recorded in the chronicles-Szechuan, Hunan and Kiangsu. This lacquer toilet box with silver inlay is a masterpiece of Han craftsmanship. It dates to the 1st century B.C.

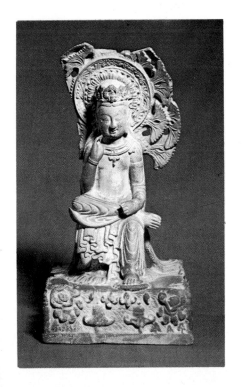

Sculpture in China was never highly regarded. It was generally considered a lesser art. In spite of this, sculptures such as this Bodhisattva Maitreya carved from marble, must surely rank among the treasures of China. It dates to the Northern Chi dynasty. The lack of regard for sculpture in ancient China probably accounts for the lack of examples unearthed in recent excavations.

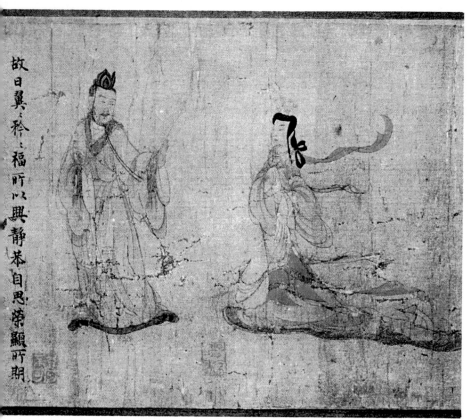

故曰翼翼矜矜福所以興靜恭自思榮顯所期

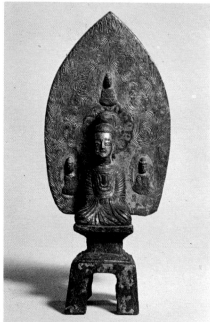

Detail of a handscroll, 'The Admonitions of the Imperial Instructress' by Ku-Kai Chih, probably the oldest surviving example of Chinese scroll painting. This beautiful work of art is attributed to the 4th century A.D.

From about the 6th century, Buddhism became the main stimulus for bronze work. Great artistry was lavished on figures of the Buddha and Bodhisattvas. This gilt bronze figure of Buddha is dated A.D. 451.

around the perimeter of buildings. The central court held the major sacrifice, the burial of five chariots with charioteers.

Human sacrifices also accompanied important burials. Outside the city, archaeologists found what appeared to be the royal rombs. They were cruciform in shape with gently sloping ramps leading from the coffin pit to the surface. At the base of the ramps was an area of about twenty two feet square. The wooden coffin had been placed over a small pit containing the bones of a sacrifical dog. All around the coffin and on the ramps human sacrifices had been placed. Horses had also been sacrificed. Some of the human victims had been

beheaded and their heads separated in a pile. In this macabre way the royal Shang tombs resemble the royal tombs of Ur in Mesopotamia, where similar rites of human sacrifice were observed.

Since 1950 the excavations at Anyang on the royal tombs have greatly added to our knowledge of the funerary customs of the late Shang period. Each tomb had ramps leading north, south, east and west from a central shaft. They were extremely rich in funerary furnishings and have yielded ritual bronze vessels, weapons, bronze bells, pottery, musical stones, horse drawn chariots etc. It appears that only in the more important and larger

Bronze ritual food vessel, "Kuei", with an inscription placing it in the 11th century B.C.

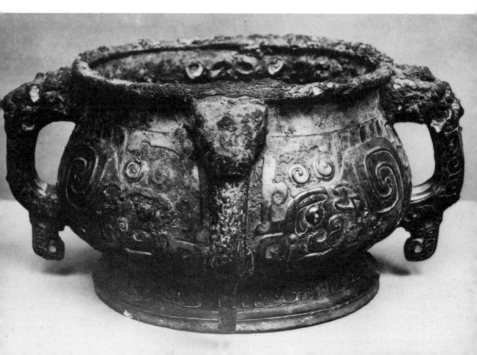

tombs are bronzes found. One tomb alone yielded the remains of more than three hundred victims, some of whom had been decapitated. From these tombs it is possible to reconstruct the scene of funerary rights. We can imagine the complex ritual that accompanied burial, with the king's retinue and even his court being interred with him. On the whole they appear to have gone into the tomb willingly, where they may have either taken poison, been slain, or buried alive. The fact that some of the victims had been decapitated may mean that they were prisoners, for prisoners from battle were often sacrificed on the altar of the earth god, in the same manner as animals.

Modern Chinese archaeologists have called the Shang and Chou dynasties, the Slave Period, suggesting that they were slave societies under rigid military rulers. They also suggest that the sacrifices were slaves. All evidence collected through archaeology is open to interpretation, and all interpretation must necessarily be influenced by personal and political ideas, whether Marxist or capitalist. Whatever the society, whoever the victims were, it cannot alter the fact that there was a class of rulers who were important enough and powerful enough to demand human sacrifice. In the same way, certain buildings, whether for individuals or for the community, were

The "K'uei" dragon, a favourite motif on ritual bronzes.

"protected" by the sacrifice of humans. While the State may have been held together by a hierarchy of kings, princes, and noblemen, it cannot be denied that it was based on the technology of the bronze smith and artisan, who produced the bronze weapons with which wars were fought, and the ritual bronzes, with which Fate was placated.

The practice of human sacrifice was mainly restricted to the Bronze Age dynasties of Shang and Chou. The practice survived nearly a thousand years, but gave way eventually to substitute sacrifices, i.e. the placing of wooden or pottery models in tombs. A vivid description of burial rites with human sacrifices is given almost a thousand years after the Shang burials by the Chinese writer Mo-tzu. He describes how, on the death of a prince, the treasury and store houses were emptied of their contents, which were buried with the deceased. Gold, jade and pearls were placed on the body, and the funerary chamber stacked with rolls of silk, drums, tables, tripod vases, ice containers, pots, swords, axes, standards, ivories and animal skins. Chariots with horses were buried and men sacrificed. "If he should be a son of Heaven, they will be counted in hundreds or tens. If he is a great officer or baron they will be counted in tens or units". The most important antiquities of the Shang dynasty are the ritual

Jade pendant in the form of an owl. Late Shang dynasty, 13th−11th century B.C.

57

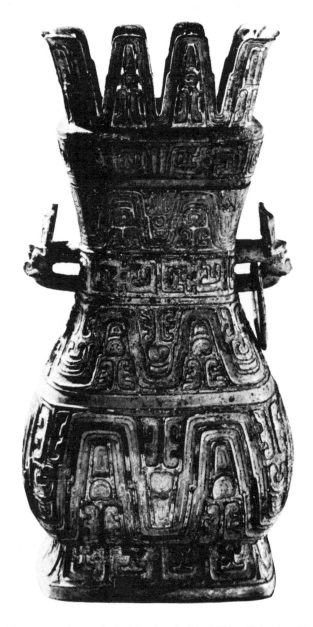

A ritual bronze vessel unearthed with others in July 1966 at Chingshan, Hupeh. Western Chou dynasty (1027–770 B.C.).

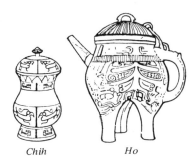

Chih Ho

Hu

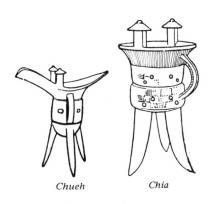

Chueh Chia

Some of the shapes of ritual bronze vessels in use during the Shang and Chou dynasties.

bronze vessels. It is therefore ironical to realise that objects of such great beauty were associated with such macabre rites.

Since 1953 Shang sites have been excavated one hundred miles south of Anyang at Cheng Chou in Honan province. Here, excavators have been able to recover stratified deposits which give us a tentative chronology, helping to link sites together chronologically. They show that Cheng Chou was earlier than Anyang. We know in fact that the Shang rulers moved their capital a number of times. The Cheng Chou excavations revealed the remains of a large rectangular earthen city wall, about 22 – 30 feet thick. When they were standing the walls would have reached a height of 22 or 25 feet. A number of tombs were found but none as opulent as those of Anyang. The bronze vessels were less sophisticated, although still quite advanced.

In recent years Shang antiquities have been found at a number of sites; in Anhwei province at Funan and Feihsi, in Honan at Huihsien, in Hunan at Ninghsiang and Changning, in Shansi at Shihlou, in Hopei at Shulu and in Hupeh at Hanyang. In 1966 a tomb was discovered at Yitu, Shantung, which contained the remains of forty-eight human sacrifices. All these excavations help recreate a picture of life at the time.

We know that there were two communities, one urban, the

other rural. The towns of the city-states were the preserve of the ruling classes, the warriors, noblemen, hunters and also the bronze workers and artisans. Bronze was monopolised by the ruling classes, the peasants continued to use tools not greatly advanced from the Neolithic period, including stone sickles and wooden spades. The dual function of Shang society of co-existing complementary town and village populations proved an important step in Chinese civilization. Shang sites mainly developed from Neolithic sites, with many of the Neolithic traditions being continued, modified and adapted by the Bronze Age communities. The discovery of bronze technology brought about division by specialisation, that is the bronze workers' settlements became nuclei, which grew into cities. With them sprang up a class of aristocratic warrior hunters. This freed the rural settlements to devote their attention to agriculture.

Much of the country was covered with forests, which were rich with game of all kinds. The farms were mainly on land that had been cleared in Neolithic times. Agriculture, however, was not a major factor in early Chinese civilization, it was the power and protection of the city that made it possible for specialised activities such as agriculture and husbandry to develop. In addition to protecting the peasants and their produce physically, the royal

"T'ao t'ieh", a favourite motif on ritual bronzes.

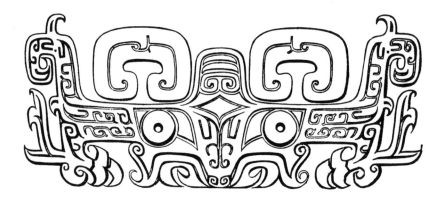

power interceded on their behalf with heaven, to ensure good weather conditions and good harvests. The king was in a privileged position with heaven, as his title "Son of Heaven" suggests. He was the central figure both of spiritual and temporal powers. In the succeeding Chou period, the nobility were graded in a rigid hierarchy. Beneath the king were the princes, then the heads of great families, under them were the barons, and on the lowest level of the hierarchy came the gentlemen.

The Shang cities all followed a similar pattern, modelled after the capital. They were not large, but each was surrounded by a beaten

The "Ting", a ritual bronze tripod cauldron food vessel. This one dates to the Shang dynasty (1523 – 1027 B.C.)

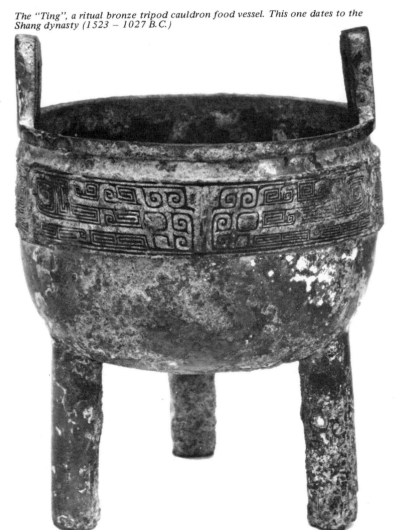

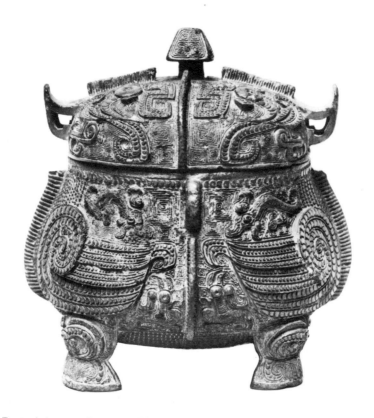

Fantastic bronze wine vessel, "Yu" in the shape of an owl. Shang dynasty (1523–1027 B.C.).

earth wall, which protected the city both from attack and from floods. The latter was necessary as the cities were nearly always built by a river. The walls enclosed a rectangular area with gateways on each side. The palace contained three courtyards, the central courtyard being the holy of holies where the most important rituals took place. North of the palace was the market area and to the south were the homes and workshops of the craftsmen and various officials.

Large numbers of ox scapulae and ventral parts of tortoise shells, which have been used in divination have been found on Shang sites. These oracle bones, first found in 1899, have been studied since that time, and we have learnt a great deal about the life of the time from the inscriptions on them. Questions on all subjects, including agriculture, military matters and private matters of the king's household were inscribed on the bones. The oracle would then heat them until they cracked, after which he would interpret the

cracks for his client. The bones had small cavities bored into them and examination of some of these has shown that the oracle could, by selecting a bone with a hole drilled in the right places, predetermine the cracks and therefore the answer.

Divination by oracle bone was all part of the complex rites of ancestor worship, as the questions were usually addressed to a particular ancestor. Over forty-one thousand inscribed pieces of oracle bones have been published. Work on deciphering the three thousand characters identified on them continues, so far more than a thousand have been successfully deciphered. Through them we

Shang burials often required human and animal sacrifice. This tomb near Anyang contained a number of sacrifices including the charioteer, who was buried with his chariot and horses.

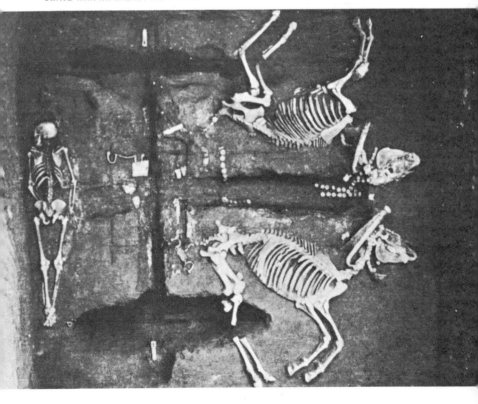

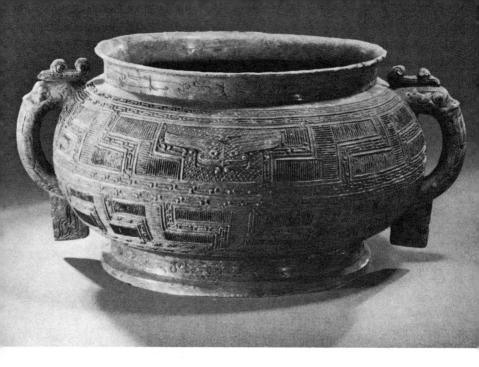

Bronze food container, "Kuei", found at Tunhsi, Anhwei.

have been able to check the traditional king lists, handed down in the ancient chronicles, which have been proved to be almost correct. One interesting fact which has emerged is that succession was passed from brother to brother, not from father to son which came later.

The Shang dynasty lasted for a period of some five hundred years, after which it was overthrown in 1027 B.C. by the state of Chou. The Chou were a kindred people and after the conquest of the Shang adopted and continued Shang traditions and culture. The Chou were not the primitive barbarians that some Chinese historians would have us believe. The ease with which the Shang culture continued suggests that they were on a cultural par before

their conquest. The traditional home of the Chou chiefs was the river valleys and uplands of Shansi and Shensi. It is interesting that there is no mention of an attack on Shang by Chou, but on the other hand, there are hints that the Shang ruler provoked attacks on Chou.

Bronze ritual vessels continued to be made, but with subtle changes in design, and with the introduction of one or two new shapes. The state religion was still centred around sacrifice to the spirits of heaven and earth, and ancestor worship. The supreme deity, T'ien or heaven had developed into a more abstract idea than the Shang Ti of the Shang dynasty. Rituals became increasingly more complex with the Chou king the central figure in

the most important.

Another class of ritual objects, first introduced during the Shang dynasty became common in the Chou dynasty. These were made of jade, a substance first carved in China in Neolithic times. In the Book of Rites, written towards the end of the Chou dynasty, six ritual objects are mentioned. They are the *Pi*, the *Ts'ung*, the *Kuei*, the *Chang*, the *Hu* and the *Huang*. Out of these the *Pi* is worth describing as it was made from the earliest times until the present day. It is a small disc pierced in the centre, sometimes plain, other times decorated. In the Shang tombs at Anyang, *Pi* were found decorated with symbols similar to those seen on ritual bronzes. Other jade objects were decorated with mystical *t'ao-t'ieh* masks and *kuei*. The *Pi*, thought by some to be a representation of the sun, symbolises heaven.

The Chou capital was situated at Tsung Chou in Shensi until 771 B.C. when a Chou city near Loyang became capital. Hundreds of small city states acknowledged the sovereignty of the Chou kings.

Recent excavations have continued to add to our knowledge of the period. During the Cultural Revolution a number of sites were excavated including Chisan near Sian in Shensi. Excavated in 1966-67 it produced a number of vessels with inscriptions. Over four hundred tombs were excavated at Peiyaotsun, suburban Loyang, Honan, but most of them had been robbed. Other excavations were carried out in 1967 in Kansu at Paitsaopo, producing amongst other things over three hundred and forty bronzes, many of them inscribed. Bronze vessels were also unearthed at Paochi, Fufeng, Meihsien, all in Shensi, Penghsien in Szechuan and Tunhsi in Anhwei.

By the seventh century B.C. the power of the central Chou state had declined, heralding a period which the Chinese call the Spring and Autumn Period.

The "K'uei" dragon, a favourite motif on ritual bronzes.

5 TREASURE OF PRINCE LIU SHENG

The Spring and Autumn Period is not so poetic as its name might suggest. It was a period of breakdown of the central authority of Chou. Some of the cities of the Chou managed to acquire vast territories, thus virtually establishing themselves as capital cities. They in fact become small kingdoms, consisting of groups of towns and villages. Power shifted to whichever kingdom was most powerful. It is during this period that we first notice the importance of the great kingdoms, which were to play an important part in China's history right up to the unification of China under the Empire. They include the kingdoms of Ch'i with its capital in a valley in north Shantung, the Chin in the Fen basin of Shansi, the Ch'in in the Wei valley (they did not become powerful until later), and the Ch'u of the middle Yangtse valley. The kingdoms of Wu and Yueh of the lower Yangtse also played an important part in the wars of the 6th – 5th centuries B.C. The wars that broke out between states were not only motivated by a struggle for power, they were in part a struggle between north and south China.

Until the wars with the Ch'u nation, violence was limited and warfare almost took the form of tournaments in which there were

Gilt bronze mythical animal. Han dynasty (206 B.C. – A.D. 220).

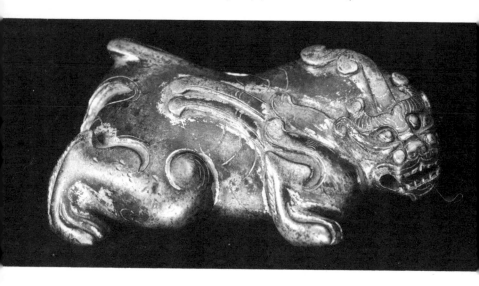

strict rules of honour. It was, for instance, dishonourable to profit from the weakness of the enemy by use of extreme force. The Ch'u changed all this, they did not recognise the rules, thus warfare became more determined. The change of conduct of warfare infact was only part of the breakdown of the social order of society, an order which had been handed down from Shang times.

During the Spring and Autumn Period, the power passed from Ch'i to Chin and in 597 B.C. to Ch'u. Later the kingdom of Wu gained ascendancy and in 506 B.C. overran the capital of the Ch'u state. They were in turn overrun by the Yueh in 473 B.C. During this period, great changes were taking place in the social structure of Chinese society. Respect for tradition lessened and the power of the nobility waned, giving way to a hierarchy based on power and wealth. Armies became professional in the pay of chiefs, while the peasants no longer had to work for the nobility without reward, but were obliged to pay a portion of their produce as taxes. A number of social reforms took place and new laws were introduced and written down.

The wars which started at the end of the Bronze Age, during the Spring and Autumn Period continued into the Iron Age and for about two hundred and sixty years we have a period which we call the Warring States period. The

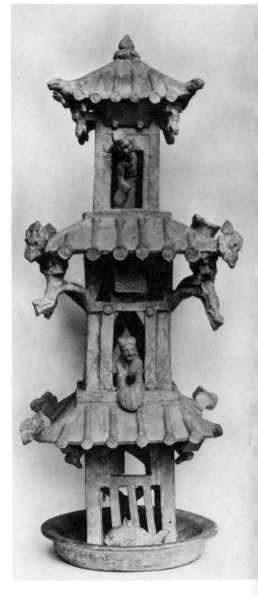

Green glazed pottery model of a watch-tower. Han dynasty (206 B.C. – A.D. 220).

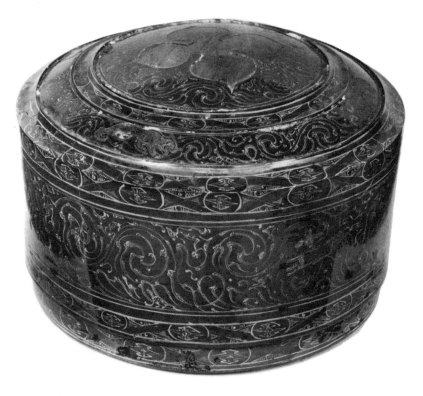

A number of very fine lacquer objects have been recovered from Han tombs. This painted lacquer toilet box is inlaid with silver. Han dynasty (206 B.C. − A.D.220).

Chin kingdom in Shansi divided into three new kingdoms, the Wei in south Shansi, Chao in north Shansi and Han in Honan. This took place in 453 B.C.

War was the major cause of change in China from the 5th to 3rd centuries B.C. Not only did methods of warfare change, with the introduction of infantry (which replaced the chariots), archers, crossbowmen and cavalry (inspired from the nomadic raiders) but also the administration and agriculture, etc. Penal reforms were introduced and codes written down. Towns were enlarged and agriculture intensified, with large scale irrigation schemes introduced. The military organisation brought about by the wars also meant that large construction programmes could be embarked upon. This resulted in an improve-

ment in communications, with hundreds of miles of roads being built and the erection of large defensive walls along the borders of states.

With the development of the art of warfare and with military organisation, a point was reached when every peasant farmer was also a soldier. A situation very similar to modern day China. In fact, as today, the masses were mobilised and China made great advances. In the China of the Warring States advances were made at the expense of personal liberty. Conditions of military service also changed and varied from kingdom to kingdom. In the Ch'i kingdom, soldiers were paid by reward, i.e. gold for each enemy head they took, while later the practice of compulsory service originated in the Ch'in kingdom, from where it spread to the other kingdoms.

The history of the Warring States period is confused, with numerous battles, coalitions and treaties. To the great warring kingdoms of the Chin (the Wei, the Han and the Chao) the Ch'in and Ch'u, was added the kingdom of Yen. Situated in Hopei, it had its capital near Peking. The kingdom of Yen was weaker than the others and only

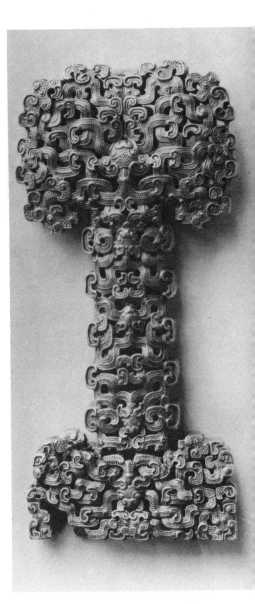

This gold openwork dagger handle of the 4th century B.C. reminds us of the preoccupation with warfare during the Spring and Autumn and Warring States periods.

69

played a minor part in events.

From the middle of the 4th century B.C. the hitherto minor kingdom of Ch'in began to gain ascendancy. Gradually, by a series of brilliant campaigns, it overthrew all its adversaries until in 221 B.C. it had conquered the whole of China, eventually unifying the country under the first emperor, Shih Huang - ti. In 1967, a bronze weight was excavated with seventeen other bronzes from Shangyuanchia, Chinan. On it was inscribed the imperial mandates of the first and second emperors, reflecting the unification of China and the establishment of a centralised government under the Ch'in.

Life in the Ch'in empire was totalitarian and oppressive. A number of great innovations were brought into being, but the strict and fanatical control exercised over the people was more than they could stand. There was general discontent. Thus, with the death of the founder in 210 B.C. the Empire began to crack and the country fell into anarchy. In 206 B.C. the Han dynasty succeeded the Ch'in and a new era began. During the Han dynasty a certain amount of the old traditions were brought back and added to the advancements made during the period of the Warring States.

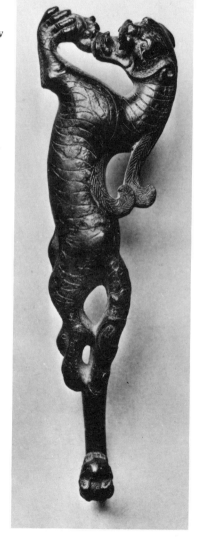

Bronze belt hook in the form of a mythical animal.

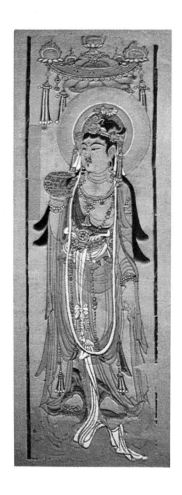

One of the most important discoveries of Chinese art was made some years ago by Sir Aurel Stein, in the caves of Tun Huang on the western frontier of China. This painting of a 'Bodhisattva with Transparent Bowl' was found sealed in a cave with a number of others, it dates to the T'ang dynasty.

In 1966 during the Cultural Revolution, some extremely fine antiquities of the T'ang period including manuscripts and silks were found at Turfan, Sinkiang.

The tomb figures of the intermediate period between the Han and T'ang dynasties show a great degree of naturalism heralding the realistic treatment of the T'ang period. This is clearly seen in this painted pottery tomb figure of a horse and rider which dates to the Six Dynasties period.

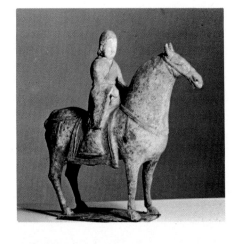

During the Sui dynasty Buddhist figures became more symmetrical and far rounder. This Sui dynasty bronze group of Buddha Sakyamuni and Buddha Prabhutaratna is dated 609 A.D.

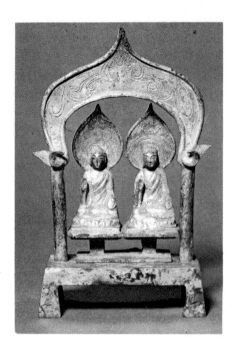

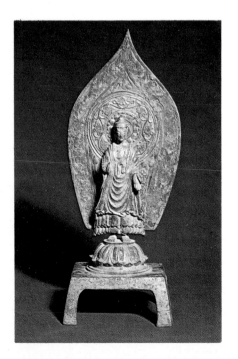

In the early part of the 6th century, during the Northern Wei dynasty, there was a change in the modelling of Buddhist figures. The body and head of the figure became thinner and more elongated, there was an emphasis on robes which became more stylized, as can be seen in this bronze figure of Buddha Maitreya which dates to the early 6th century A.D.

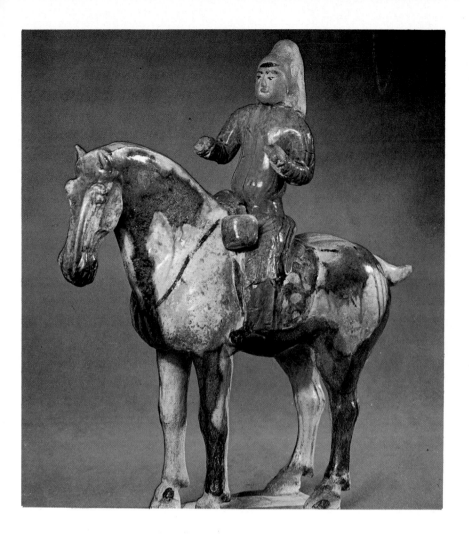

The cosmopolitan atmosphere of T'ang China is reflected in the subjects chosen for some of the tomb figures. As well as horses with Chinese riders such as this, there are some which depict foreigners from the Near and Middle East and Central Asia. During the recent Cultural Revolution many of these pieces were found in tombs near the frontier along the 'Silk Road'. Some of the tomb figures were coloured with cold pigments while others like this beautiful horse and rider, were glazed and decorated with most vibrant colours.

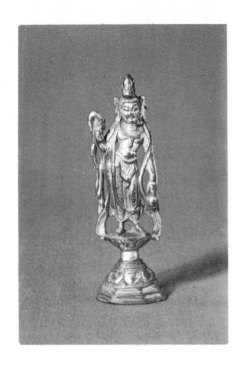

Gilt bronze figure of Bodhisattva Avalokitesvara dating to the T'ang dynasty. While some T'ang figures have been preserved in temples or in private collections, others have been recovered from excavations. Hordes of T'ang antiquities, including Buddhist figures have been unearthed during the Cultural Revolution.

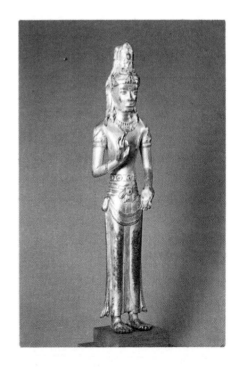

Buddhist figures of the T'ang dynasty have a distinctive style, dissimilar to those of earlier periods. This gilt bronze figure of Bodhisattva Avalokitesvara shows a strong influence of Indian Gupta artistic ideas. It dates to the 10th century A.D.

Some of the most spectacular archaeological discoveries of recent years were of antiquities belonging to the period of the Warring States and the Han dynasty. Excavations during the Cultural Revolution have greatly enhanced our knowledge of this period, by uncovering a number of sites.

Sites in all parts of China have been explored, some old and well known and others new. Between 1969 and 1970 excavations were carried out at Houma in Shansi, on sacrificial pits of the state of Tsin. The pits, dating to about the 5th century B.C. produced a number of finds, as well as bones of sacrificial horses, oxen and sheep. Among the objects recovered were a number of jade blades. Nearby, in the same area, archaeologists uncovered several tombs dating from the middle to late Warring States period. Reports on this dig suggest that the tombs contained a number of "sacrificed slaves"

The well known sites of the tombs of the State of Ch'u at Changsha, Hunan, in the Yangtse valley, have been explored and a new tomb discovered. During the

A group of glazed pottery tomb figures of men playing a game. Han dynasty (206 B.C.–A.D.220).

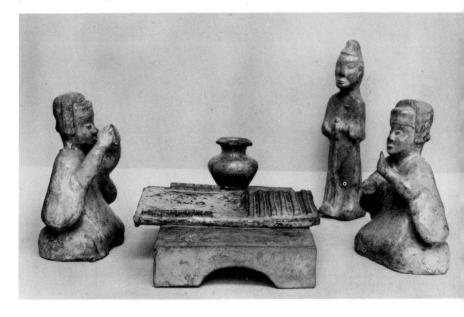

Spring and Autumn Period and the Warring States period, Changsha was an important city. Situated on the southern border of the State of Ch'u, its tombs have added greatly to our knowledge of the material culture of the period by preserving large collections of objects, many of which are now in museums throughout the world. Very fine examples of early lacquerware were found during the early excavations, including a most unusual group of lacquered wood tomb figures.

In February 1971, a new tomb was discovered at Liuchengchiao by local people helping archaeologists. As a recent discovery, the tomb is of such interest that it is worth describing in detail. It appears to be much older than other tombs of the Warring States period found at Changsha, dating to the late Autumn and Spring Period or the very early Warring States period.

When opened, the tomb which measured about 18 feet by 12 feet, was found to contain about two hundred and seventy objects of funerary offerings and furniture. Everything had been

Bronze chariot pole finial inlaid with gold and silver, excavated from Chin − ts'un 5th − 4th century B.C.

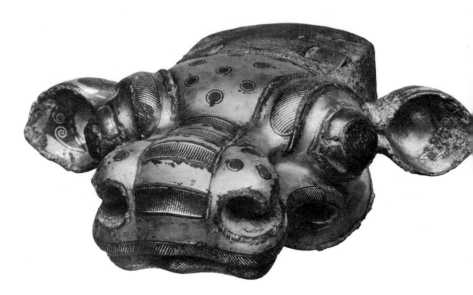

well preserved, as they had been sealed by a preservative layer of white clay.

The body lay in a nest of three wooden coffins. The outermost coffin lay about 22 feet beneath ground level and was made out of square blocks of cypress wood, layered one on top of the other. The corners were held together by bronze nails in an intricate arrangement, rather like a jig-saw. Inside lay the middle coffin. Also of wood, its boards were over 3 inches thick, dovetailed together and fixed with bronze nails. The inner coffin was of different form. Measuring over 7 feet long, 2 feet 7 inches wide and 36 inches high, it too was made of wood, but its sides and lid were made of three crescent-shaped section boards. This is an unusual feature for Ch'u tombs. The coffin was painted black on the outside and red inside.

The finds give us a very good idea of the material culture of the time. There were objects of pottery, bronze, lacquer, bamboo, jade, as well as textiles. The pottery consisted of food containers, cooking pots, wine vessels, basins and water jars. One cooking pot was decorated with an impressed cord pattern. As with other Ch'u tombs, this one did not fail to delight the dis-coverers with the lacquerware it preserved. There were lacquered tables, platters, chariot canopies, figures, including finely engraved lacquered wood gargoyles, and a series of figures of deer lying down with their heads tucked in. A fine twenty-three stringed zither or *se* was also found. Also of great interest were the silk fabrics which promise to add to our knowledge of textile weaving of the time.

It is the bronze objects, though, that remind us of the unsettled times in which the tomb was constructed, for they are almost all weapons. As such, they are of considerable interest as some of them reflect the changes that were taking place in warfare at the end

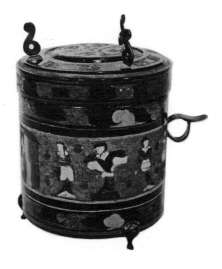

Painted lacquer toilet box unearthed at Changsha, Hunan. 5th century B.C.

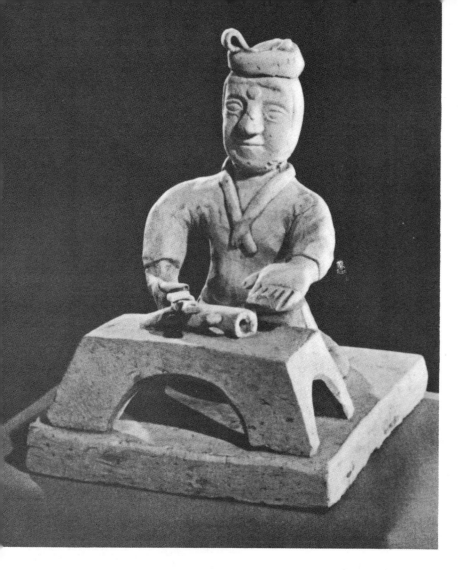

Pottery tomb figure of a man cleaning fish. Found at Wuchang, Hupeh, Kingdom of Wu. (A.D.220–280).

of the Spring and Autumn Period and the beginning of the Warring States. They include examples of the dagger-axe, *ko*; the spear, *mao*; the halberd, *chi*, as well as arrowheads and chariot trappings.

Ninety-three weapons in all were recovered, more than a third of the total contents of the tomb.

The weapons in the Liuchengchiao tomb give us some idea of warfare at the time. The *ko* or

dagger-axe head had been used since the Shang and Chou dynasties, when it was the principal weapon. The outer blade was used to thrust, and the inner blade to hook or hack. The shafts of the *ko* found in the tomb varied from about 10 feet to 3 feet in length. The principal weapon of the Spring and Autumn Period and the Warring States period was the *mao* or spear, mainly used for thrusting. The shafts were of wood or rattan, their lengths about 9 feet. The rattan shafted *mao* is unique, as all others found before have had wooden shafts.

The halberd or *chi* was a favourite in the Spring and Autumn Period and the Warring States period. It was a weapon which embodied developed features of both the *ko* and *mao*, and thus could be used both for thrusting and hacking. The shaft lengths of the weapons determined whether they were to be used on foot or from a chariot. If the latter, the shaft would normally be longer.

The *shu* was a pointed edgeless weapon for chariot warfare. It was made from a substance made from agglutinated bamboo skin. The two examples found in the Liuchengchiao tomb measured about 9 feet 9 inches in length.

Ancient texts mention the "five weapons of chariot warfare" which were mounted on both sides of the war chariots. It seems highly likely as chariot trappings

are included in the finds, that the weapons represent a set of chariot armaments. Also included amongst the weaponry in the tomb were several bamboo bows of different sizes, quivers and arrows with three kinds of heads, prismatic, leaf and three barbed.

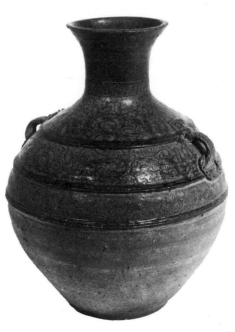

Glazed pottery began to be common during the Han dynasty (206 B.C.– A.D.220) when vessels such as this glazed earthenware jar were made.

Probably the most spectacular discoveries of recent years were the tombs of Liu Sheng, Prince Ching of Chungshan of the Western Han dynasty (206 B.C. – 24 A.D.) and that of his wife, Tou Wan.

Situated in the Lingshan Mountain in the western suburb of Mancheng, Hopei, the tombs were discovered and excavated in July, August and September of 1968. Liu Sheng died in the fourth year of Yuan Ting, 113 B.C. He was the elder brother of the Han emperor Wu Ti. Notorious for his corruption and depravity, he was described in the *Shih Chi,* the *Historical Records,* as being "fond of wine and women".

Liu Sheng's tomb was discovered by accident by soldiers of the People's Liberation Army stationed at Mancheng. The find was immediately reported and a top level decision made for excavations to be carried out. The work was undertaken by a team from the Institute of Archaeology of the Chinese Academy of Sciences, and the Archaeological Team of Hopei Province with help from soldiers and local residents. Stone chippings on the sparsely vegetated mountain side marked the presence of the tomb. A short distance away, about three hundred feet from Liu Sheng's tomb, further chippings were found marking the presence of another tomb, which proved to be that of his wife Tou Wan.

Lingshan Mountain is a little over six hundred feet high. The tombs, which proved to be of gigantic size were cut deep into the rock. Both tombs were found to be sealed with a wall of iron, an amazing feature. It appeared that after the tombs had been blocked with stones they were sealed with molten iron! This wall of iron had been cast on the spot, an amazing achievement at such an early date. At this stage it is worth discussing this feature which dramatically illustrates the technological superiority of Han China. Their iron technology was far in advance of the West. Iron was smelted in massive furnaces in state foundries, while in Europe, early iron working was restricted to wrought iron at blacksmith's forges. Smelting and casting did not make its appearance until the Middle Ages.

While entry could be made into Liu Sheng's tomb through its roof, which had already been exposed, the iron wall made entry into Tou Wan's tomb extremely difficult. Eventually the discoverers resorted to the most drastic method, they blew up the iron wall with dynamite!

What met the archaeologists when they entered the tombs must

Right:
The central chamber of the tomb of Prince Liu Sheng of Chungshan of the Western Han dynasty, discovered in 1968 at Mancheng, Hopei.

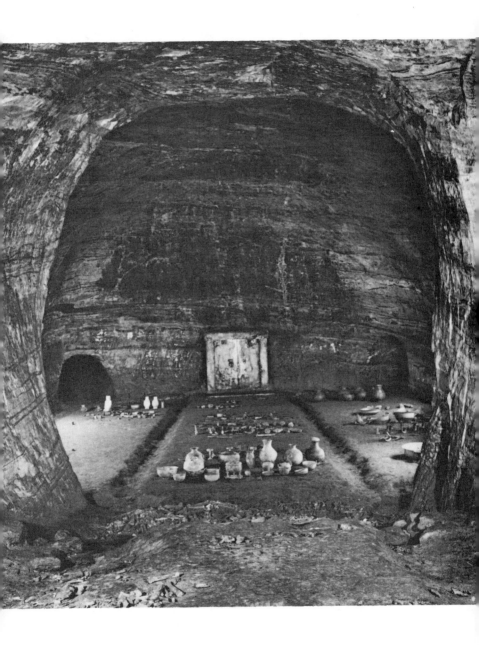

have truly staggered them, for between them the tombs contained over two thousand eight hundred wonderful objects, treasures of great beauty. Prince Liu Sheng could be called the "Tutankhamun" of Chinese archaeology.

The tombs were massive. Liu Sheng's measured 170 feet long, 121 feet wide, and 23 feet high, approximately 473,000 cubic feet. Tou Wan's tomb was even larger. The massive dimensions of these tombs illustrate the ruthless organisation with which large construction projects were carried out. These were only the tombs of one man and his wife and yet they must have employed the labour of hundreds of men to hack them out of the cliff. Even using modern techniques, it has been estimated that the construction of the tombs would take several hundred men a year to complete. When we add to this solitary work the numerous roads, cities, canals

Jade funerary suit of Prince Liu Sheng made from 2,690 pieces of jade, sewn together with 1,110 grammes of gold thread.

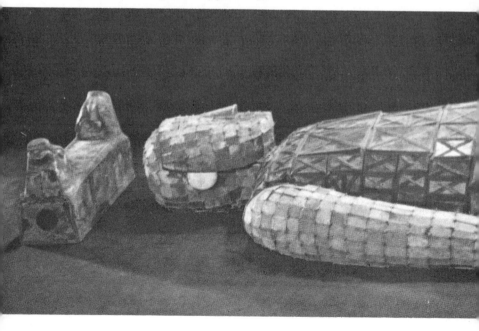

and defensive works that were constructed during the period, we are staggered by the estimate of manpower and resources that they must have consumed.

Both tombs appear to have been constructed during the life times of Liu Sheng and Tou Wan, who must have watched over the construction with considerable interest. The shape of the two tombs is similar, each is divided into a central chamber with a long underground passage entrance and two antechambers, one on the southern side and one on the northern. There is also a rear chamber to the west. The central and antechambers had originally held a wooden structure with a tiled roof, but by the time of the discovery these had collapsed. The rear chamber contained a stone structure with slanting roof.

The large central chamber of the tombs contained a wide variety of funerary furniture, laid out in an orderly fashion,

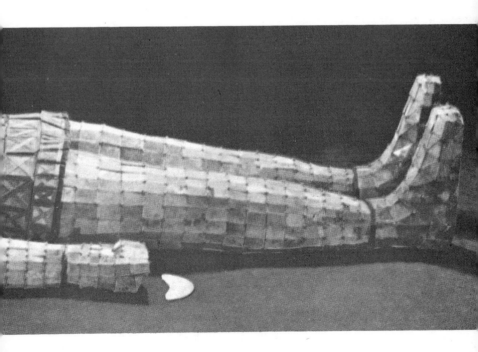

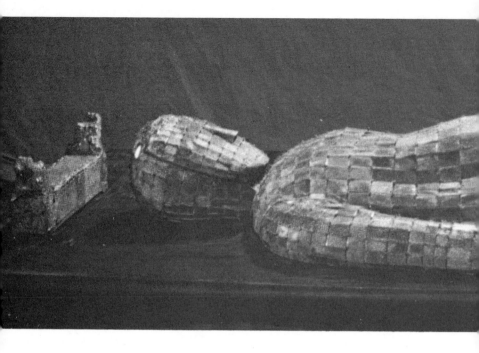

Liu Sheng's wife, Tou Wan, was also buried in a jade suit, but hers was smaller with only 2,156 pieces of jade sewn together with 703 grammes of gold thread.

including bronze vessels, lacquerware, pottery and a number of stone and pottery figurines. The most fabulous objects were placed with the coffin in the rear chamber. The south chamber of Liu Sheng's tomb contained several chariots, together with the remains of a dozen horses. The north chamber contained hundreds of pottery food and wine vessels.

Some of the objects found in the tombs are of breathtaking beauty and quite unique. The fascinating gilt bronze Ch'ang Hsin lamp from Tou Wan's tomb is really quite remarkable. It takes the form of a palace maid who holds a lamp in her hands. The lamp is quite ingenious for the intensity of light can be controlled by adjusting the lamp shade. The figure of the palace maid is hollow and the head detachable. Her right hand and arm, which hold the top of the lamp are also hollow and designed to feed the smoke from the lamp into the hollow body, keeping the room free of smoke. Its name Ch'ang Hsin, meaning "eternal fidelity" comes from two characters inscribed inside.

Other remarkable finds include a gold inlaid Poshan incense burner. The lid is formed like a mountain scene in which game is

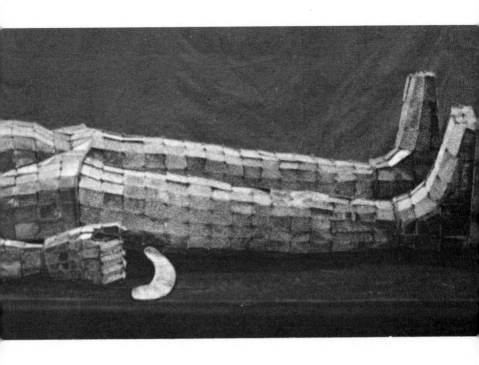

pursued by hunters. The majority of the bronze objects are unsurpassed in beauty and workmanship, many of them inlaid with gold.

The most spectacular of all the finds are the jade funerary suits of Liu Sheng and Tou Wan. These are not only spectacular, they are also unique and very beautiful. From ancient texts we knew that jade suits or "jade cases" were used for burials of Han emperors and high ranking aristocrats, but none had ever been found. Here was a case of archaeology confirming the chronicles.

When found the suits appeared to be a pile of jade, for the bodies that they were intended to protect had decomposed and collapsed. When dummies were inserted into the suits, they became majestic, somewhat macabre jade figures. The suits were composed of thousands of small jade plates sewn together with gold thread. Liu Sheng's contained 2,690 pieces of jade and 1,110 grammes of gold thread, Tou Wan's 2,156 pieces of jade and 703 grammes of gold thread.

The jade plates were brilliantly made. Each one had been cut with a fine saw (of a thickness not greater than 0.3 mm.) and had one millimetre holes drilled at the corners with a sand drill. Each

piece was beautifully worked so that they fitted together perfectly, making the armour-like suits. Jade is an extremely hard substance and takes great skill to work. It is estimated that it would take an expert jade worker more than ten years to make one suit.

This bronze wine vessel, "Hu", with an eagle-head neck and lid was unearthed at Chucheng, Shantung. Warring States period (475–221 B.C.).

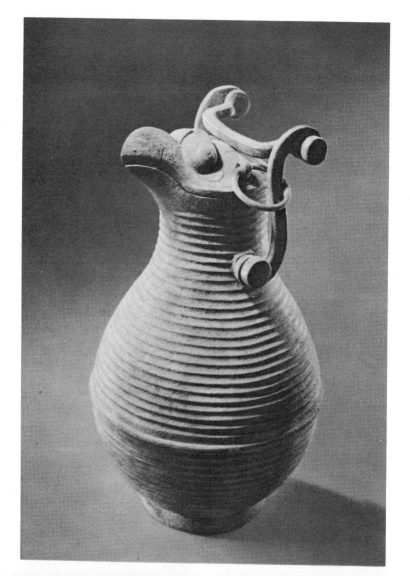

The excavation of the tomb of Liu Sheng and his wife is another example of archaeology helping to illuminate the history of the time by clarifying and confirming the ancient texts. Apart from providing objects illustrating the material culture of the time, they have also thrown light on social economics.

One of two bronze water jugs from Tou Wan's tomb had the price tag inscribed on it, 840 cash. When one considers that this was a great deal of money, more than double the annual poll tax on a five member family, we can see how expensive tombs such as these were in terms of manpower and resources. The tombs have now been preserved as site museums.

There have been less spectacular discoveries of Han tombs both before and after the Cultural Revolution and all are valuable, each in their way helping to paint a clearer picture of the period.

In 1969 an interestimg tomb belonging to the Western Han dynasty was excavated at Tsinan in Shantung. It produced a

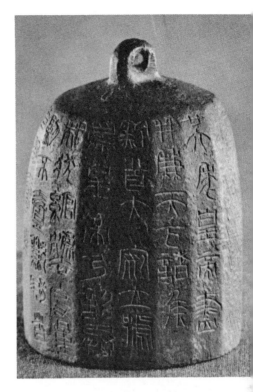

Top Right: *Bronze weight inscribed with the Imperial Decrees of the first and second emperors of the Chin dynasty (221–207 B.C.).*

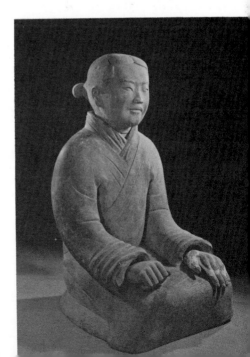

Right: *Pottery figure of a lady excavated from Lintung, Shensi. Chin dynasty (221–207 B.C.).*

unique pair of pottery vessels, birds with a *Hu* and *Ting* mounted on their wings. Numerous pottery tomb figures of aristocrats and musicians were also found. In 1970 a tomb of the Eastern Han dynasty dating to the first year of Yung Ch'u, A.D. 107 was discovered at Michih in northern Shensi.

In 1955 a modest Han tomb was discovered at Lei Cheng Uk, Kwangtung, part of present day Hong Kong. It was excavated by the Hong Kong University under Professor F.S. Drake. The tomb, found during the course of modern development, consists of four chambers laid out in the form of a cross. The central chamber is square and has a vaulted domed ceiling, while the others are barrel shaped with vaulted roofs. Fifty eight pottery and bronze objects were found including food vessels, cooking vessels, models, a bronze mirror and small bell. The tomb probably dates to the middle of the Eastern Han dynasty, the end of the 1st century A.D. to the middle of the 2nd century A.D. The tomb is worth mentioning as it is the only one that can readily be visited.

Excavation of Han dynasty sites in China has not been confined to tombs, nor of course have the finds come solely from excavations, a number of chance

An unusual gilt bronze ornament of men dancing, unearthed at Chinning Yunnan. Western Han dynasty (206 B.C.–A.D.24).

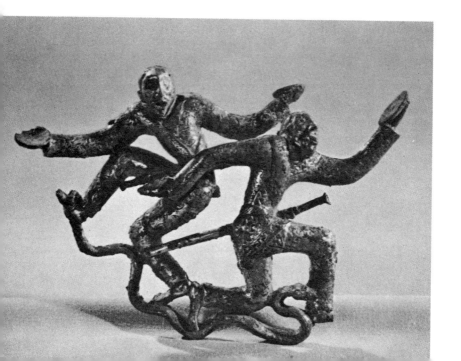

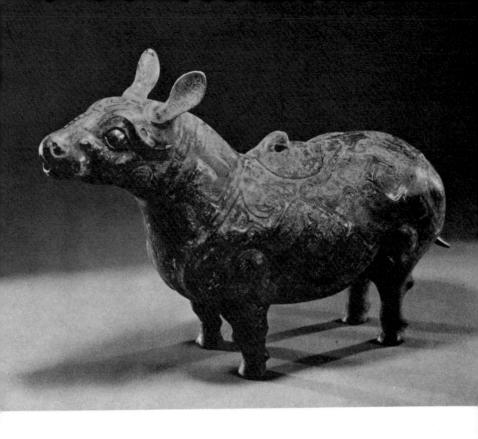

Bronze animal shaped wine vessel, "Tsun", inlaid with silver, found at Lienshui Kiangsu. Western Han dynasty (206 B.C.–A.D.24).

finds have been made. A member of the commune in Hsincheng, Honan, discovered two square bronze wine vessels while irrigating fields. The vessels, which weighed about seventy pounds, belonged to the Spring and Autumn and Warring States periods (770 – 221 B.C.)

Archaeological activity has not been restricted to excavation alone. When in 1969 the Pao-Hsieh path across the Chinling Mountains was threatened by an irrigation project, a major rescue operation was carried out. The path, which crosses the mountains, runs from the southern end of the Pao River valley northwards to the end of Hsiehku valley in Meihsien. Built some two thousand years ago, the path winds up and down the rocky mountainside along riverbanks and through a tunnel. In the tunnel and on the sides of the cliffs were numerous inscriptions and graffiti which date to the Han and Wei dynasties (206 B.C. – 280 A.D.). These were photographed and recorded, chiselled out of the rock and removed to a place of safety. When it was impossible to

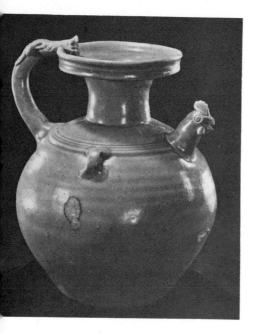

remove the inscriptions, rubbings or casts were taken.

An extremely rich cache of antiquities of the Eastern Han dynasty was found at Leitai in Wuwei. It contained a vast number of gold, bronze, lacquer, iron, jade and bone objects, some of great beauty. In all two hundred and twenty pieces were found. Perhaps the most outstanding was a superb bronze figure of a horse. This figure is full of life, and action with its head held high and its tail flying in the wind. Three hoofs are in the air while the fourth rests on a flying swallow, symbolising its speed. Of perhaps equal beauty and interest are fourteen bronze chariots, seventeen bronze vases and forty five bronze chariot drivers.

Under the Han emperors, China began to reach out beyond her frontiers and became a world power. Unified, the Chinese who had spent the last few hundred years fighting each other, now

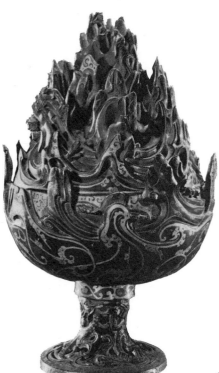

Top Left: *Celadon glazed pottery jug with a spout in the form of a Chicken's head, found at Yuyao, Chekiang.*

Left: *Poshan incense burner from Liu Sheng's tomb, discovered in 1968 at Mancheng, Hopei.*

90

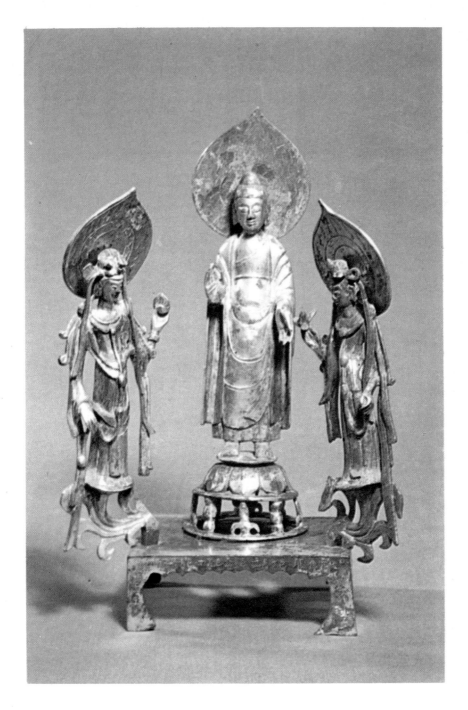

Buddhist figures of the Sui dynasty are more symmetrical and the face rounder. This fine Sui gilt bronze Buddhist Trinity, Buddha Amitabha with Bodhisattva Avalokitesvara and Mahasthamaprapta, is dated 597 A.D.

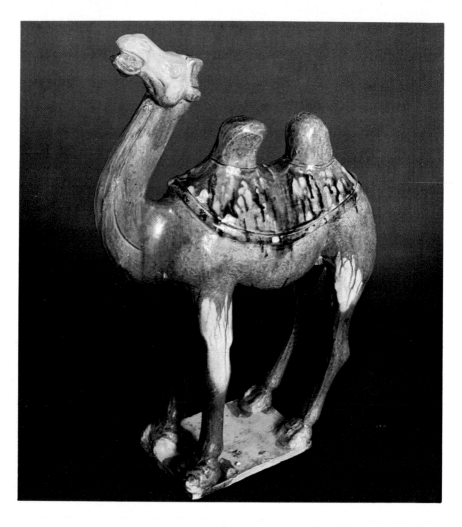

T'ang tomb figures were unearthed in large numbers during the beginning of this century when the Lung Hai railway was constructed. In recent years over 140 T'ang tombs have been excavated at Turfan, Sinkiang by the regional museum.

Both the horse and camel were favourite subjects of the T'ang artists who were masters of ceramic sculpture such as this camel. T'ang figures are dynamic, naturalistic and extremely plastic.

began to expand into areas outside the traditional borders of China. Through this expansionism, ideas from outside, especially India, began to influence Chinese thought.

The change in the traditional social order of the archaic period had also been accompanied by new philosophical ideas. Confucianism began to have a profound influence, over three hundred years after the death of Confucius. The scholarly ethics of Confucianism influenced both government and the arts.

The gilt bronze "Eternal Fidelity" lamp found in the tomb of Tou Wan at Mancheng, Hopei in 1968.

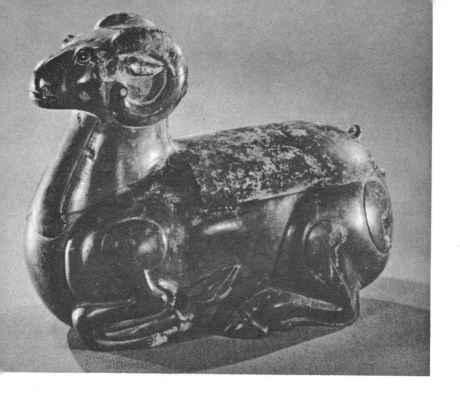

Bronze lamp in the shape of a ram, discovered in the tomb of Liu Sheng, Prince Ching of Chungshan, at Mancheng, Hopei in 1968.

Government servants had to be cultured men of letters, versed in Confucian scholarship and were expected to have an interest in the arts, both literary and artistic. These changes had a profound influence on Chinese culture for centuries.

Contacts with the outside brought with them another philosophy/religion, Indian Buddhism, which was later to play an important part in China's history. This expansionism also brought the Chinese into closer contact with the nomadic "barbarians" of Central Asia.

Contact with the energetic art forms of the nomads was reflected in Chinese art, especially that from the Ordos region.

During the Han dynasty, some types of ritual bronzes continued to be made, but they were not used for the old rituals, knowledge of which had been all but wiped out during the Ch'in period. The force of the earlier decorative motifs had been lost to the foreign nomadic artistic influences which exerted themselves during the period. With the artistic influences of the Steppes came a

Pottery jar with celadon glaze, excavated from Nanchang, Kiangsi.

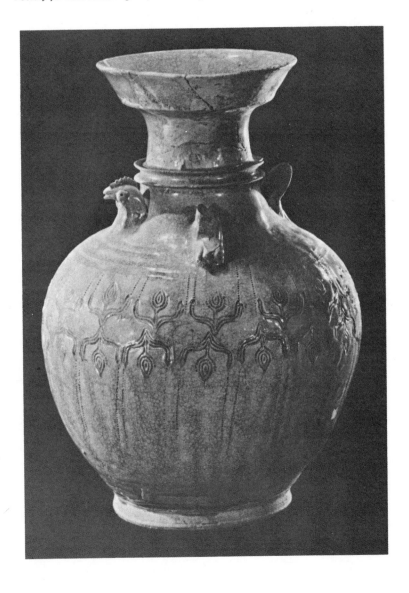

tendency for increased naturalism. Although sometimes accentuated and embellished with stylised motifs, the animal or human figures when portrayed are instantly identifiable.

Bronze mirrors, circular discs with ornamental backs and loops for suspension, were made during the Han as well as the Chou dynasties. Some archaeologists have suggested that the idea of mirrors may have been introduced into China by the Steppe nomads, who had borrowed the idea, in about the 5th century B.C. from the Greeks on the shores of the Black Sea. However, as a bronze mirror was recovered from a Shang tomb at Anyang, which is of a much earlier date, we must conclude that mirrors may have been invented independently in China at an early date, the Greco/ Steppe idea only acting as an additional stimulus.

The genius of Han design and decoration is evident on many of the lacquer objects found in tombs. The fantastic designs were usually painted in red lacquer on lacquer of a soft brown colour. These fine lacquer objects reflect the sophistication of the everyday life of the upper classes of the period.

Animals such as this mythical creature were popular during the Han dynasty. This gilt ink-slab case was found at Hsuchow, Kiangsu.

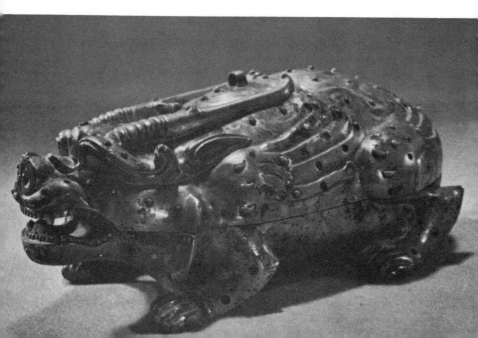

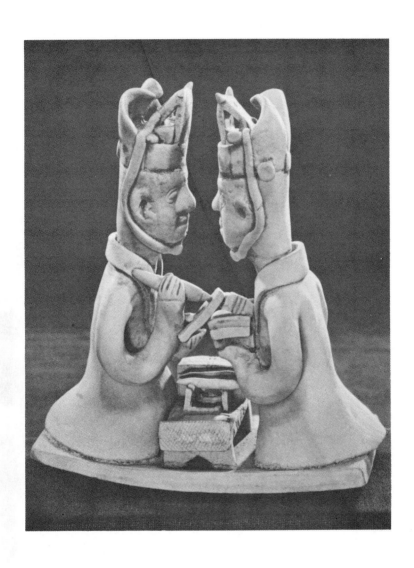

An amusing pottery model of two scribes writing at a table, unearthed at Changsha, Hunan. Western Tsin dynasty (A.D.265–316).

With the exception of certain marble sculpture from Anyang and the wooden figures from Changsha, we can say that sculpture in China starts in the Han dynasty. Unlike painting, sculpture was never highly regarded, but was generally considered a lesser art. Han bas-reliefs are extremely interesting as they help to give us a pictorial idea of the life of the time. The subjects are invariably mythological or historical, but are depicted in contemporary settings. The general style of the reliefs suggests that they were renderings on stone of contemporary paintings or similar medium and this provides us with ideas of the appearance of paintings that have long since disappeared. A large number of reliefs were found in the Wu Liang tombs in Shantung. A few sculptures in the round have also been found. Probably the most important are the large statues of horses, dating to about the 2nd century B.C., carved from boulders, at the tomb of General Ho Ch'u-ping in the valley of the Wei River at Shensi. The carving is rather rough, but indicates that in addition to executing bas-reliefs, Han artists were quite capable of

monumental sculpture in the round.

Sculptures of a much smaller size have been found in numerous tombs. They are of course the pottery figures which by Han times had replaced the human sacrifices placed in earlier tombs. The figures were not rigid and lifeless but extremely plastic. They were sometimes modelled in groups, othertimes singly, each

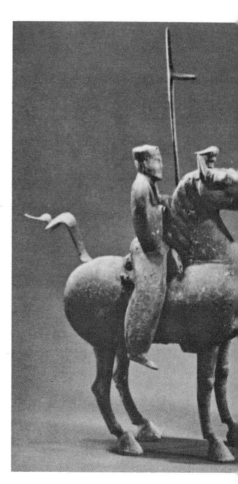

Three equestrian figurines, part of the hoard of bronze horses and chariots found at Wuwei, Kansu. Eastern Han dynasty (A.D.25–220).

showing some of the pursuits and pleasures of life which the deceased had enjoyed on earth. Subjects were varied and included musical scenes, games, dancing etc. Animal figures and models of houses, estates and domestic equipment were also made and although most were naturalistic, some of the buildings were highly stylised sometimes to the point of being ornamental.

After almost four centuries, the Han dynasty began to weaken its hold on the country. This inevitably created a situation where power was usurped and the country fell into a period of disunity, with northern and southern dynasties. This period is known as the Six Dynasties period. It was to last until the establishment of the T'ang empire.

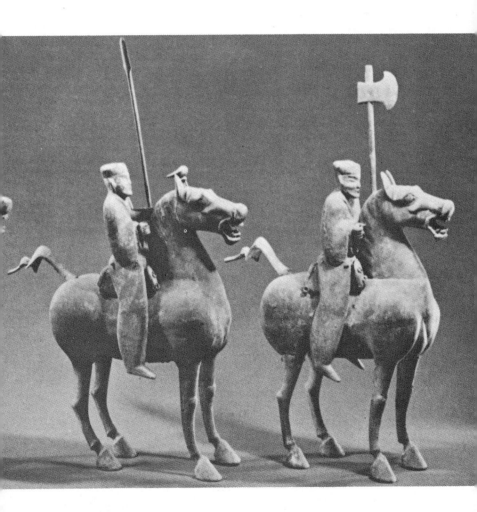

6 GOLDEN HOARD OF THE PRINCE OF PIN

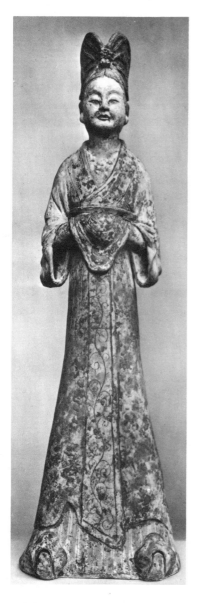

The period of strife and disunity which followed the break up of the Han dynasty marked the beginning of Buddhism in China. The unsettled times brought with them chaos and poverty and people clung eagerly to this new religion from India by which they hoped to regain peace and stability.

In north China, the Chinese were coming under increasing attack from the nomadic tribes. They made numerous attempts at alliances, even to the extent of giving gifts of food and weapons as a form of tribute, to try to keep on friendly terms with the "barbarian" tribes. However, they were unsuccessful and in A.D.311 Loyang, a large city of over 600,000 people was overrun, and this part of China at least was conquered.

In the south, China went through a period of a number of short dynasties. The northern horsemen found the climate and terrain unsuitable for them, and after a number of unsuccessful campaigns left the area alone. In the north, Buddhism gained a hold, mainly because the conquered Chinese people had lost faith in both Confucianism and Taoism, while the rulers found that the Buddhist monks were the only educated body whom they could trust to help

Painted pottery tomb figure of a lady.
T'ang dynasty (A.D.618–907).

them govern. The northern invaders were soon well indoctrinated both with the Buddhist faith and Chinese culture, which they had rapidly assimilated.

The most important of the northern dynasties, the Northern Wei dynasty (A.D. 386-535), was founded by the T'o-pa tribe; and the most successful of the southern dynasties was the Liang (A.D. 502-577).

From the Six Dynasties period (A.D. 280-589) onwards, religion became the major stimulus for artistic works, and large numbers of sculptures in bronze and stone were produced. This is in contrast to the art of the earlier periods, which was centred on the worship of ancestors and earthly deities. Now, the stimulus was Buddhism,

The T'ang horse is a noble creature full of spirit, as can clearly be seen in this tomb figure of a prancing horse.

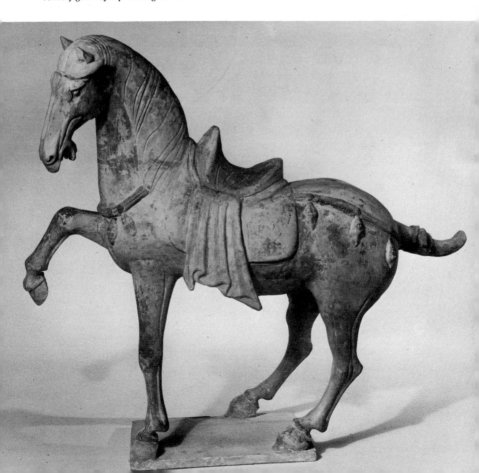

*Porcelain ewer with a phoenix head.
T'ang dynasty, 10th century A.D.*

and Buddhist images were commissioned for both personal worship and for installing in temples.

In north China, at Yun Kang, Ta-t'ung-fu, Shansi, great cave temples were constructed with gigantic figures of the Buddha and Bodhisattvas carved out of the limestone rock face of the gorge. These early sculptures of the Buddha follow the Indian Gandhara style which had been modified to suit Chinese taste. The work at Yun Kang seems to have begun about the year A.D. 460 and continued until after A.D. 494, when the Northern Wei emperor moved his capital from Tai (Ta-tung) to Loyang. The Gandharan style can be clearly seen in the early works at Yun Kang, but the later ones are in mature Northern Wei style. Many of the figures are dated by

inscriptions. Further sculptures were carved in the cliffs at Lungmen after the court had moved to Loyang. The caves at Lungmen have sculptures dating from the late 5th century to the mid 8th century.

The Wei style is marked by its obsession with elaborate robes, which are carved in tiers with parallel folds. The bodies of the figures are elongated and angular, but more attention is paid to the robes than the form beneath them. The face is squarish, set on a long neck, and the eyes mere slits with no pupils. There is an enigmatic smile on the lips.

In contrast to this style of sculpture are the monumental animal sculptures of the Liang dynasty of south China, characterised by the colossal figures which stand in front of the Royal Tombs outside Nanking. These figures are full of vitality despite their huge size. The subjects, winged lions with bulging chests and tongues hanging from their mouths, are reminiscent of the monumental sculpture of earlier epochs in the Near East.

The earliest Chinese bronze figure of the Buddha found to date, is dated A.D. 338. The early Buddhist bronzes of China were strongly influenced by the iconographic styles of the Gandhara region of north-west India and of Central Asia. Buddhist iconographic canons were adopted in China and all images that were made had to

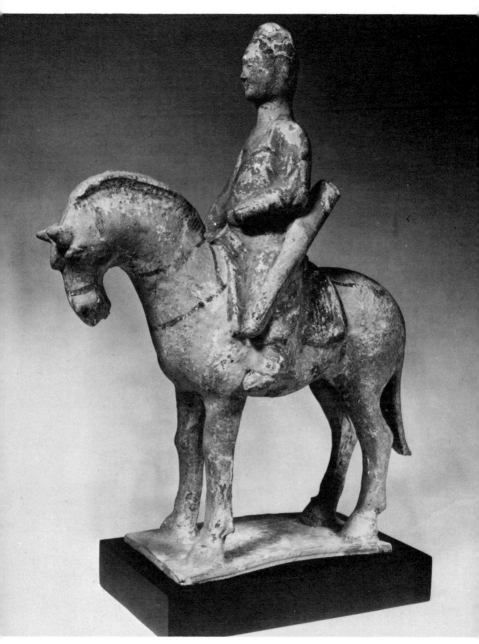

Painted pottery figure of archer on horseback, unearthed from a tomb of the T'ang dynasty (A.D.618–907).

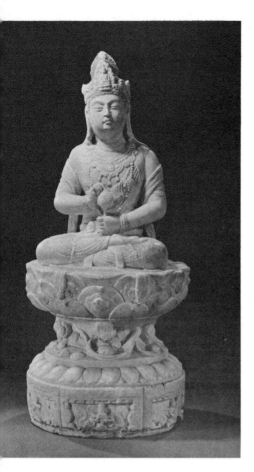

Marble sculpture of the Bodhisattva Avalokitesvara, found at Sian, Shensi.

conform to the specifications laid down for their particular type. To standardise representation of abstract forms, specifications were laid down for the proportions of the figure, each relative to each other. In this way an artist who had never seen an image of the Buddha, could, by using the specifications produce an acceptable representation.

One of the most important discoveries of Chinese art was made at the turn of the century by the explorer-archaeologist Sir Aurel Stein at the caves at Tun Huang, on the western frontier of China with Central Asia. Here paintings, both scrolls and frescoes of a number of periods were found.

The "Caves of the Thousand Buddhas" at Tun Huang, are extremely important to our knowledge of Chinese art. The work here, dating from the 4th century A.D. is Buddhist, and it is here that we can clearly see the impact of religion on the art of China. From the Han period, Tun Huang grew in importance as a military, political and commercial centre. Thus situated, with trade links with countries to the west, it is not surprising that the influence of Buddhism was felt early in its history. The caves are supposed to have been started in the year A.D. 366, after a monk called Lo Tsun had a vision of the "Thousand Buddhas" appearing over the mountain tops of Tun Huang.

Numerous caves were carved out of the soft limestone over the centuries and decorated with paintings. A fine set of paintings of the early 6th century A.D. were discovered in the twenty caves of the Wei dynasty. These paintings illustrate the continuation of early tradition of figurative and landscape painting.

The artist Ku-K'ai-chih is recorded to have painted a number of Buddhist temple frescoes, but although the paintings at Tun Huang are in the tradition of the period, they must be regarded as provincial work of somewhat lower standard. They could not, therefore, be compared with works by Ku-K'ai-chih.

The discoveries at Tun Huang were made a number of years ago. More recently, archaeologists have unearthed further important sites of the Six Dynasties period.

In 1965 and 1966, the tomb of Ssuma Chin-lung was excavated at Tatung, in Shansi. Ssuma Chin-lung died in A.D. 484. His tomb preserved a number of beautiful

The back of a bronze mirror decorated with a design of two phoenixes holding flowers, found at Huhsien, Shensi. T'ang dynasty (A.D.618—907).

Treasure of the Prince of Pin. This onyx rhyton was part of a hoard unearthed at the Palace of the Prince of Pin, in Sian, Shensi, in 1970.

objects some of them most unusual, including stone, lacquer, pottery and porcelain objects. Of interest was a wooden screen with lacquer paintings, two pairs of sculptured stone pillar bases, a coffin platform decorated with reliefs, and a number of glazed pottery vessels. There was also an unusually large number of pottery tomb figures, both glazed and unglazed.

A tomb of the Northern Chi dynasty (A.D. 550–577) was opened at Anyang in 1971. It belonged to Fan Tsui, governor of Liangchow, who died in A.D. 575. Excavated evidence of

this short period of Chinese history is rare, and the contents of the tomb has increased our knowledge of the material culture of the time. The pottery is of great interest, it includes several early celadon glazed vessels and a pair of brown glazed pilgrim flasks with a design of dancers and musicians moulded onto the flat surfaces. Pottery tomb figures were also found.

China was unified again in A.D. 589 with the foundation of the Sui dynasty. The dynasty did not last, however, giving way in A.D. 618 to the T'ang dynasty (A.D. 618–907) and more settled

times. The Chinese had learnt from their earlier mistakes. Under the T'ang emperors the borders were secured, not by negotiations and treaties but by conquest. The beginning of the T'ang dynasty was marked by a period of expansionism. The Turks were subdued in the north, the "barbarian" tribes in the west, Tibet became a Chinese protectorate and Chinese armies marched in the Oxus valley and Upper Afghanistan. Under the emperor Ming Huang, the Chinese were even in conflict with the Arabs in the west. Thus the T'ang empire stretched beyond the borders of traditional China forming buffer states. Chinese influence reached out far and wide, in return the Chinese felt the artistic influence of the subjected "barbarians".

The T'ang capital was situated at Ch'ang an. It was the centre of a vast empire and amongst its inhabitants of over a million were men from many other lands. T'ang China was a Mecca to the less advanced peoples of neighbouring lands, who strove to copy and adapt T'ang ideas and culture to their own needs. T'ang China was in fact a major civilizing force to many of the surrounding lands.

It was a period of great artistic exuberance. Great literary works were written, foreign works translated and works of art commissioned. During the T'ang dynasty, Buddhism reached its zenith. Its influence, both on social and artistic thought was never again equalled.

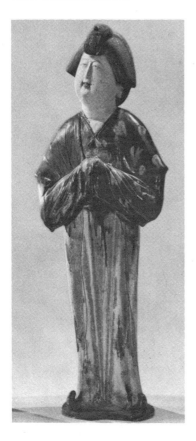

Pottery tomb figure of a woman covered with a three colour glaze. Discovered at Loyang, Honan. T'ang dynasty (A.D.618–907).

The cosmopolitan atmosphere of T'ang China is clearly seen in the many archaeological and artistic treasures of the period, especially some of the recent discoveries.

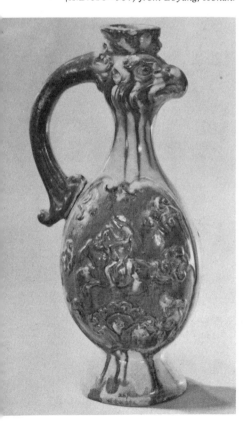

In 1970 a large hoard of T'ang antiquities, including gold and silver vessels was unearthed at the site of the palace of the Prince of Pin, Li Shou-li, in Hochiatsun, a southern suburb of Sian, Shensi. Li Shou-li was the cousin of the emperor Hsuan Tsung. Two large pottery vessels were found containing over one thousand objects, including jewellery, precious stones, jade, Chinese and foreign coins, and gold and silver vessels. A quantity of medicinal minerals were also found, including cinnabar, litharge, stalactite, and amethyst.

Apart from its immense intrinsic value, its archaeological value is incalculable. Gold and silver vessels accounted for a fifth of the finds. These beautiful vessels were delicately made by craftsmen using a number of techniques. Some were worked by repoussé, that is hammering out the design from inside the vessel, others by casting and yet others by using combinations of techniques including tracing, openwork, filigree and granulation. Some of the silver vessels were gilded. The influence of Sassanian Persia can clearly be seen in the designs and shapes.

The designs were of great beauty, the craftsmen drawing their inspiration from nature and everyday life. Some of the vessels bore designs of floral and animal motifs including lions, horses, bears and birds. Hunting scenes were also popular. A pair of gold

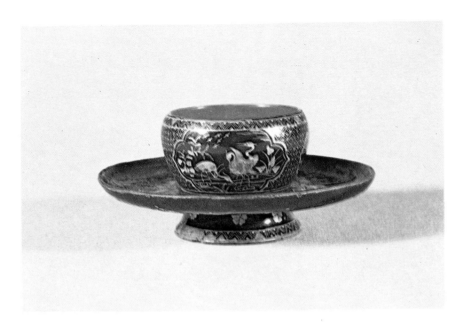

In 1970 several beautiful lacquer objects of the Ming dynasty were uneàrthed in the tomb of Chu Tan, Prince of Lu of the Ming dynasty, however lacquer objects of this period such as this cup stand are extremely rare.

Ming carved lacquer covered box attributed to the reign of the Emperor Yung Lo (1403 – 1424).

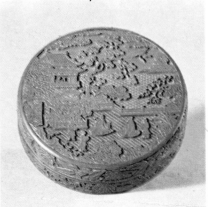

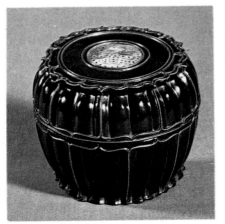

Our knowledge of Yuan lacquerware mainly comes from Chinese and Japanese documentary sources, as lacquer such as this covered box is extremely scarce.

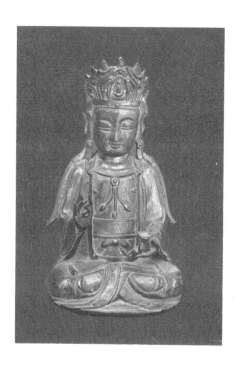

The bronze figures of the Ming dynasty are icons in the purest sense of the word. They are formal and the faces sometimes have a sublime smile, characteristics clearly seen in this fine gilt bronze seated figure of a Bodhisattva.

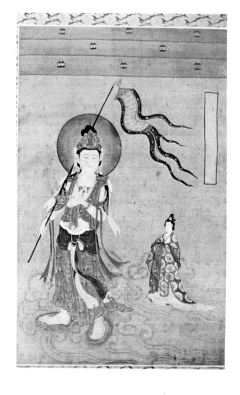

The caves at Tun Huang on the western frontier of China, have preserved many fine works of art, such as this painting in the T'ang style of Bodhisattva Avalokitesvara as 'Guide of Souls'.

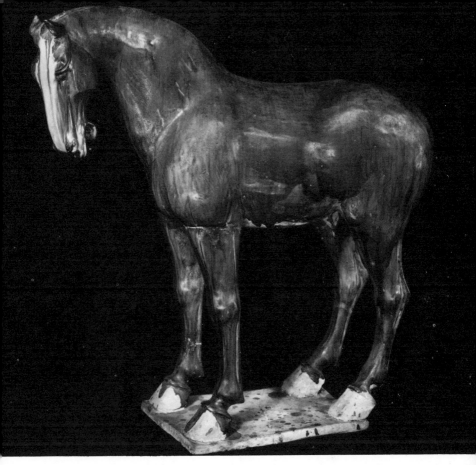

The superb pottery tomb figures of horses made during the T'ang dynasty are masterpieces of Chinese art, and rival Greek renditions in their mastery of spirit and movement.

hexagonal cups had a design of musicians and dancers in high relief. The shaps of the vessels were many and varied including six-lobed bowls, stem cups, lotus shaped bowls, peach shaped dishes, ewers, winged cups and the hexagonal cups mentioned above.

Although foreign influence can clearly be seen in the designs and shapes of the vessels, they are definitely Chinese in origin. On the other hand, there were a number of finds of undoubtedly foreign origin, including a most beautiful onyx rhyton with a gold spout, which is of Central Asian origin; a glass bowl, a Sassanian silver coin of Chosroes II (A.D. 590–627); and a Byzantine gold coin of Heraclius (A.D. 610–641). Links with the east were illustrated by five Japanese silver coins minted in A.D. 708. The latest dates in the hoard were inscribed on silver discs, one was

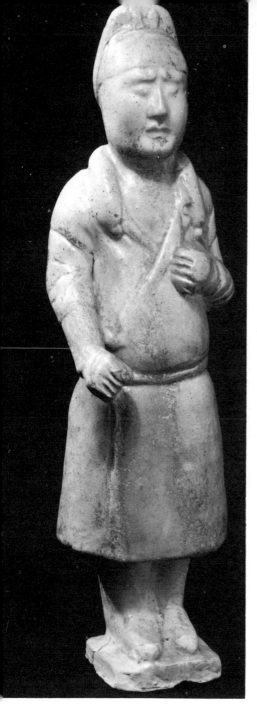

inscribed "19th year of K'ai yuan" (A.D. 731).

Chinese archaeologists have used the evidence recovered from the hoard to reconstruct the events which led to its burial. They believe that after the attack by An Lu-shan on Ch'ang an, in the 15th year of T'ien Pao (A.D. 756), a member of the family of the Prince of Pin buried the hoard before fleeing to Szechuan with the emperor Hsuan Tsung, and the court. Whoever buried the hoard may well have been killed or died unexpectedly as no attempt was made to retrieve it. An Lu-shan was a "barbarian" Turkish leader who, in A.D.755 revolted against the Empire. The revolt was the beginning of the decline of the T'ang empire, because although it was put down with the help of "barbarian" troops, the Empire no longer had a firm hold on the outer provinces.

A discovery of a less spectacular nature, but of great interest archaeologically, was made between 1969 and 1971, when the remains of the Hanchia state granary were discovered and excavated at Loyang, the eastern capital of the T'ang dynasty. Although the find was of a utilitarian nature and did not reveal any great treasures, it has

T'ang pottery tomb figure of a man.
Figures of all nationalities and
occupations were made including
dancing girls, servants, merchants etc.

shed light on the economic history of the T'ang empire.

The granary located north east of the Loyang palace was the T'ang equivalent of the national treasury. It covered an enormous area, enclosing four hundred round storehouses. These were within a large encircling wall and were arranged in symmetrical rows. They were of different sizes, varying from 20 feet to 59 feet in diameter and 16 to 32 feet in depth. One of the largest could hold 10,000 *tan,* that is 600,000 litres of grain.

In some of the storehouses archaeologists found the remains of decayed millet. When the granary was operative grain would have been sent to it, mostly as taxes, from all parts of China, including Yenchow, Soochow in Chekiang in the south and Chichow and Hsingchow in the north. Thanks to a strict administrative system, interesting information has been obtained from a number of inscribed bricks which record the name and status of the storekeeper, the quantity of grain stored, the

Blue splashed glazed figure of a horse. T'ang dynasty (A.D.618–907).

month it was stored and its position in the granary. Most of the bricks date to the end of the 7th century (A.D. 692 – 699).

Construction of the granary began before the T'ang dynasty, during the first year of the emperor Ta Yeh (A.D. 606) of the Sui dynasty. Excavations showed that the storehouses were sunk into the ground and were specially designed to allow the grain good ventilation and prevent it from becoming damp and rotting. This was achieved by lining the walls with wooden boards and constructing a false wooden floor about 18 inches above the ground. No evidence of the roof structure was found.

Perhaps the most common of all T'ang antiquities are the tombs and a great many have been discovered over the last fifty years. Most have been plundered and their contents sold to museums and collectors in various parts of the world. This unfortunate state of affairs has changed and now the excavation of tombs, when found, promises to answer many questions which have been posed by the earlier illicit diggings.

T'ang tombs have preserved beautifully glazed and painted pottery tomb figures and glazed pottery vessels. It is these figures and pottery vessels that are so highly prized by collectors.

During the early part of the century, a large number of tomb figures were unearthed from tombs during the construction of the Lung Hai railway. Many of the figures in museums and collections throughout the world were found at this time. Once on the open market, the figures created a demand that could only be satisfied by illicit digging or faking. It is interesting to note that some very fine fakes were produced, some even finding their way into museums.

The superb plasticity of T'ang modelling can be seen in this painted pottery figure of a female musician.

During the T'ang period, tomb figures were made in very large quantities. Compared with those of the Han dynasty, T'ang figures are far more realistic. They are dynamic, naturalistic and extremely plastic. The potters of the T'ang dynasty were masters of ceramic sculpture and their skill and artistry is clearly seen in the figures which seem endowed with a sense of life and movement. They illustrate the cosmopolitan attitude of T'ang China as some depict foreigners from the Near and Middle East and Central Asia. Subjects were many and varied. Animals were favourites, especially the horse, camel and ox. The T'ang horse is a noble creature, full of spirit. They are shown prancing, snorting, rearing, magnificent studies of equine anatomy. These superb models of horses are amongst the masterpieces of Chinese art, and rival Greek renditions in the mastery of spirit and movement. Sometimes they are shown with riders, either Chinese or foreign.

Glazed pottery tomb figure of a lion. T'ang dynasty (A.D.618–907).

Human pottery figures of all nationalities and occupations were also made, some of the best known being of dancing girls, musicians, servants, dwarfs, guards and beggars. All were accurately portrayed by the T'ang artists. The realistic non-iconographic treatment of these figures is in complete contrast to the formal religious sculpture of the period. One reflects the everyday life of the period and the other the high spiritual ideals of contemporary philosophy.

The advances in pottery technology were used to great effect by the ceramic sculptors. Most of the figures are covered with delightful glazes of green, brown, cream and yellow, often merging with each other to create a running or mottled effect. The pottery body was only lightly fired and can usually be marked with a finger nail. Unglazed figures are painted with unfired pigments

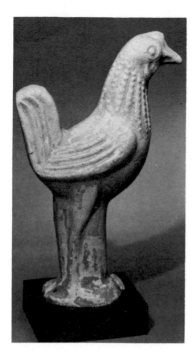

Models of birds and animals were popular during the T'ang dynasty (A.D.618–907). This model of a chicken was recovered with others from a tomb.

of white, red, green and black. Most figures are hollow cast.

The ceramic art of T'ang China was far ahead of other countries, not only in the Far East but also in the world. Cream and orange-brown glazes had been added to the green of the Han dynasty and olive-brown of the Yueh ware. The glaze was applied thickly to the vessels, so that it slowly ran down, leaving the lower part of the cream, almost white body, unglazed. Foreign designs greatly influenced Chinese potters, especially shapes of

Sassanian Persia. The technology of the T'ang potters reached its apex in the 10th century, when they developed pure porcelain. This was achieved by using kaolin, a fine white clay and firing at high kiln temperatures. Vessels in this early porcelain have a beautiful creamy white glaze.

The lacquer of the T'ang period is extremely rare. Most lacquerware was for personal use and perished with age. Little or no lacquer was placed in tombs as ceramics had become fashionable as tomb furniture. No examples of T'ang lacquer have been published from recent excavations.

Numerous tombs have been excavated in the famous Astana and Karakhoja cemeteries at Turfan in Sinkiang. Between 1966 and 1969 over one hundred and fourteen tombs, dating from the 5th to 6th centuries A.D. were found and excavated. Apart from the usual finds expected from such tombs, there were a few objects of great interest. These included documents and silk textiles, which normally do not survive. The silk fabrics were exceptionally well preserved, and include silk damask and a silk with designs dyed by batik. Batik is the process of decorating a fabric by dying, masking various areas not to be coloured with wax. In this way a multicoloured design can be built up.

Another find of importance from this tomb was a manuscript

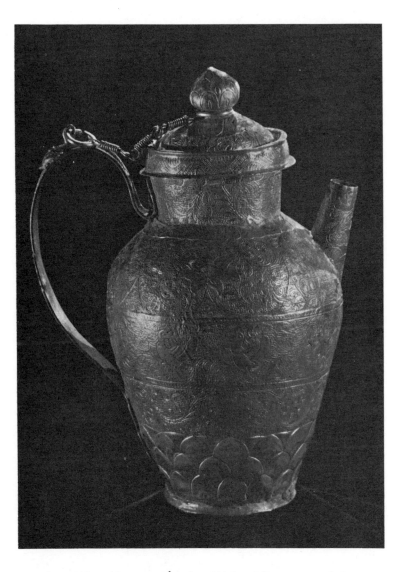

A superb gold jug with a repoussé design of birds and flowers, unearthed at Hsienyang, Shensi. T'ang dynasty (A.D.618—907).

of the Analects of Confucius with annotations by the famous Han dynasty scholar Chen Hsuan (A.D. 127 – 200). The 5.2 metre scroll was copied in A.D. 710 by Pu Tien-shou of the T'ang dynasty. Although it lacks the first chapter and part of the second, it is most important as it is the oldest copy of the Analects in existence, predating those found in the caves at Tun Huang by Sir Aurel Stein.

In the 7th century it was said that there were more than one thousand caves at Tun Huang, but present day surveys have shown this to be an exaggeration, the number being only four hundred and eighty six. Historical events had their effects on Tun Huang, and all of them have left their mark in some way on the art preserved there. From A.D. 777 until 848 Tun Huang came under the protection of Tibet. After one of the greatest persecutions of Buddhists in A.D. 845, under the emperor Wu Tsang, it again became an important centre, and religious works were produced there. During the Buddhist persecution of A.D. 845, over 45,000 temples were destroyed and about 275,000 priests and nuns were obliged to leave the priesthood.

Before the persecution, Buddhism had taken a firm hold and become the major stimulus for artistic works. Buddhist bronze figures of the T'ang dynasty have a distinctive style, dissimilar to those of earlier periods. Although the style is clearly influenced by Indian iconographic ideals, bronzes of this period have the typical Chinese look of the T'ang style, reminiscent in a way of the pottery tomb figures. The images are somewhat more formal, with roundish faces, thick lips, slit

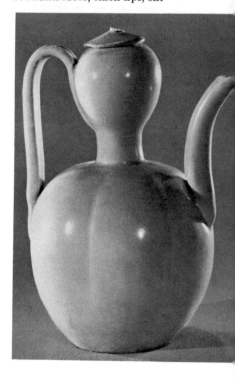

White porcelain gourd-shaped ewer of the Five Dynasties period (A.D.907– 960) unearthed at Changsha, Hunan.

118

curved almond shaped eyes, sometimes with heavy lids, and bow shaped brows, sometimes shaped with the line of the nose. The hair of images of Buddha is usually in tight curls, although some T'ang figures have hair without curls or waves. The diaphanous flowing robes have Indian overtones and the overall effect of the images is one of spiritual serenity.

During the T'ang dynasty, the art of the Chinese sculptor reached its zenith. The figures are less rigid than those of preceding periods, and although they conform to strict iconographic rules, there appears to have been .more individuality, which reflects the sculptors' ability to work within strict iconographic dictates with greater freedom. The lofty aspirations of the T'ang sculptors produced works endowed with physical attributions of great beauty, in an effort to create works of art which enable the onlooker to have an aesthetic experience as a way of achieving spiritual harmony. Spiritual beauty, in fact, was expressed in physical terms.

T'ang sculptors were equally at home sculpting animals as they were with Buddhist figurative work. In style they are essentially realistic. The individuality of each animal is well expressed, whether domestic or wild, and the characteristics of the animal superbly portrayed. The spirit of the horse, with all its restlessness

and power is expressed with superb skill. These skills were employed to great effect on the life size relief panels found in the tomb of the T'ang emperor, T'ai Tsung. The sculptures, which date to A.D. 637 are in deep relief and depict the Emperor's favourite chargers.

After the revolt of A.D. 755 under An Lu-shan, the power of the T'ang empire began to decline although China continued to be comparatively prosperous and peaceful for over one hundred and fifty years. However, in the 9th century things were really bad, the country was under constant attack from the "barbarians" in the north and west, and the internal economic situation was so bad that the peasants were forced to revolt. A period of uprising and unease followed until the dynasty finally ended in A.D. 907.

It had been a time of great advances, a renaissance of art and literature, a truly "golden age", but like so many things in China, things that began well ended in disaster. The death of the T'ang dynasty was only political, for its influence on the arts continued. The Empire again split up. In the north from A.D. 907 − 960 five successive dynasties were established but they only lasted for short periods, while in the south there were ten. We know this period as the Five Dynasties period. It lasted until the establishment of the Sung dynasty in A.D. 960.

7 MING TREASURE

With the end of the T'ang dynasty, archaeology no longer makes history, it only helps to confirm and clarify it. The history of China is amply documented, and numerous volumes exist both on history, philosophy and the arts. Archaeology can, however, make history come alive by uncovering some hitherto missing link or fact, or, as in the case of Tatu, by uncovering an ancient capital city; and in the case of the tomb of Chu Tan, by finding material remains of a man whose existence until recently had only been known from history books. Both these finds have been made in the last few years by Chinese archaeologists.

Tatu was the capital city of the

Porcelain pillow in Tzuchow ware, decorated with a design of a boy fishing. Found at Shingtai, Hopei. Sung dynasty (A.D. 960—1280).

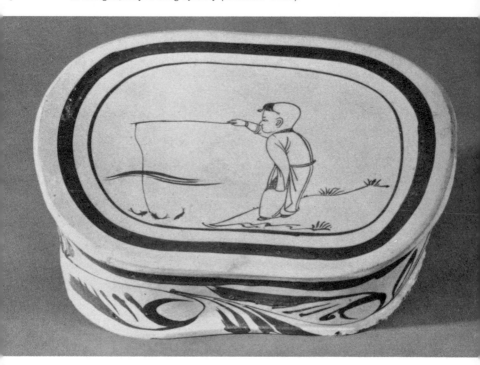

Yuan dynasty (A.D. 1280 –
1368). After the fall of the last of
the Five Dynasties, the Sung
dynasty was founded in much the
same way as other dynasties of
the period, but unlike the others,
its founder was much wiser, with
better ideas of how the country
was to be governed. Thus the
Sung dynasty became firmly
established. The system of
government was reorganised with
all.administration, political and
military powers centralised.
Confucian administrative ideals
were developed and a system of
public civil service examinations
perfected. For almost one hundred
years, the Sung empire was at
peace, during which time it
became quite prosperous. This
eventually changed, as trouble
came once again from the north.

In A.D. 916, the Khitans, a
northern "barbarian" people had
established an empire in Inner
Mongolia. By A.D. 1004 they had
expanded until they controlled
northern Hopei. This period is
known as the Liao dynasty
(A.D. 916 - 1125). The rulers
established their capital on the
site of present day Peking and
called in Nanching, "Southern
Capital". They adopted many
Chinese customs and institutions.
As well as adhering to
Confucian ideals they were also

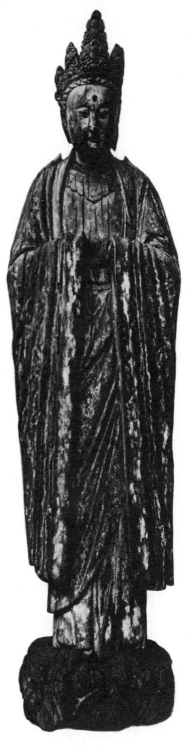

*Wooden sculpture of a Taoist deity
Sung dynasty (A.D.960–1280).*

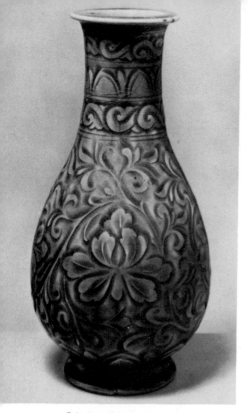

Celadon vase decorated with a floral design incised under the glaze. 12th–13th century.

Buddhists. The dynasty did not last, however, and in A.D. 1122 it was wiped out by one of its vassals, the Tungusic Jurched, aided and abetted by the Sung.

The dynasty they established was the Chin dynasty (A.D. 1122 - 1234). They soon turned on the Sung, however, and captured the Sung capital of K'aifeng in A.D. 1126 together, with the Emperor. The Sung court moved south and established itself at Hangchow. Soon both the Chin and Sung were swept away by other northern "barbarians", this time the Mongols. The Yuan dynasty (A.D. 1260 - 1368) was established by Kublai Khan, grandson of Jenghis Khan who in 1189 had taken over the leadership of the Mongol warriors. The Chin took refuge in Manchuria to reappear in the 17th century as the Manchu conquerors of China.

The Mongols, though a band of nomadic warriors, soon settled down and ruled China with the help of Chinese officials. It is a terrifying thought that had they not chosen to change their ways, the civilization of China would virtually have been raised to the ground. Happily, like other northern invaders before them, they chose to stay and reap the rewards of conquest. They established their capital at Peking, north east of the old Liao capital and called it Tatu "Great Capital"

Work started on building the capital in the 4th year of the reign of Chin Yuan, A.D. 1267. The plan of the city was on a grand scale, its fame spread beyond the borders of China and it became a wonder of the ancient world. After the end of the Yuan dynasty, the southern half of Tatu was rebuilt and incorporated into the Ming dynasty capital of Peking, which in turn was also used in the Ching dynasty. Thus Tatu was the predecessor of modern Peking and much of the ancient city lies buried under the modern city. With the redevelopment of the city, and especially with the construction of the underground railway system,

archaeologists have been uncovering a number of sites dating to the Yuan dynasty, and have gradually been able to piece together evidence to create a vivid picture of the ancient capital.

Between 1965 and 1969 Chinese archaeologists surveyed and partly unearthed the ancient city. The work was carried out by the Institute of Archaeology of the Chinese Academy of Sciences working in conjunction with the Peking Municipal Archaeological Bureau. After years of surveying and examining the city walls, rivers and lakes, a series of excavations were carried out which uncovered the foundations

Porcelain incense burner on tripod legs, covered with a celadon glaze. Found at Pinhsien, Shensi.

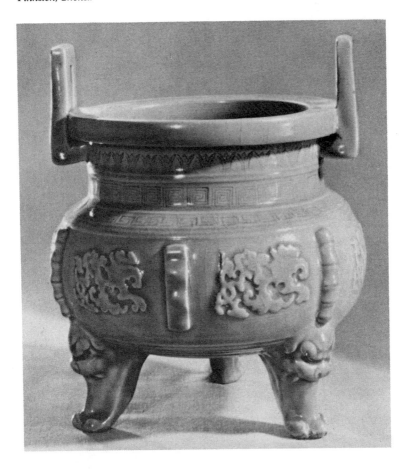

of dozens of buildings. A particularly large excavation was carried out on the barbican entrance to Ho Yi Men, "the Gate of Harmony and Righteousness" and at a number of sites behind Yung Ho Kun "the Lamasery of Harmony and Peace".

From excavations and examinations carried out at key points in the city, archaeologists have been able to ascertain the structure and outline of Tatu's outer walls. It appears that the city was of rectangular form, with its axis running north-south. This was the same as the axis of Peking during the Ming and Ching periods. Excavations have revealed a section of the Tatu north-south road, north of Ching Shan. The perimeter of the city wall covered a distance of 17.8 miles. The walls were constructed of rammed clay,

Pot in white porcelain with floral design. From Chihfeng, Liaoning. Chin dynasty (A.D.1122–1234).

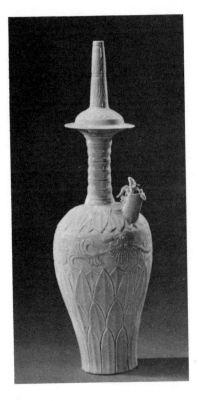

White porcelain water pot in Ting ware found at Tinghsien, Hopei. Sung dynasty (A.D. 960–1279).

and were extremely wide at their base. The city's southern section of the western and eastern walls corresponded to that of Peking of the Ming and Ching periods, while the southern wall was south of the present Ch'angan Boulevard. Remains of the northern wall was traced at "Earth City" in the northern suburb of Peking where it is still visible. There were eleven city gates of Tatu, three in the southern wall, three in the eastern wall, three in the western and two in the northern wall. The Imperial City lay in the centre of southern Tatu. To the east was the Yuan Palace City, which lay south of the T'ai Ho Tien, the "Hall of Supreme Harmony" in the Palace Museum.

The recent excavations have uncovered the Chinshui River water gate, one of the points from which the city obtained its water. The Chinshui system supplied water to the palaces, while the other waterway of the Kaoliang T'unghui Rivers and Haizu lake was also the waterway by which tribute rice was sent to the city. Excavations have revealed the route of the Chinshui watercourse in the city and shown that it silted and dried up in a number of places in Ming times.

In 1970 an open drainage system was found at Hsi Ssu, west of the central north-south road. The drain, which measured approximately 3 feet wide and 5 feet deep was built of stone and

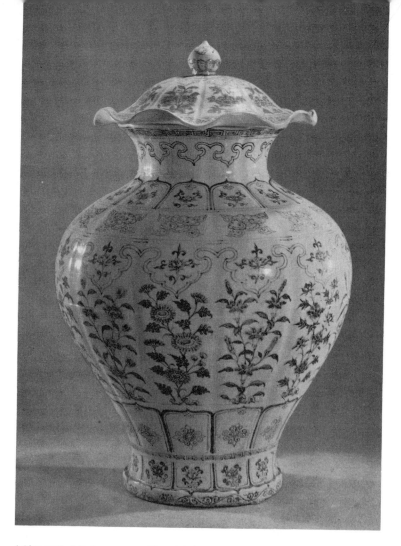

*A blue and white large covered jar with floral design, found at Peking.
Yuan dynasty (1280–1368).*

was covered by capstones at junctions and crossroads. An inscription was found on one of these stones which dated it to 1328, "Stonemason Liu San, fifth moon, the first year of the reign of Chih Ho". Two stone covered drains were found to run along part of the central section of the eastern city wall and along the northern section of the western wall. Both had been built before the massive walls had been constructed.

Marco Polo was full of praise for the city, which he called "Taidu" or "Cambulic" (Khanbalic) when he visited it

Lacquer from the Ming dynasty
is nearly always red and generally
decorated with floral designs, as is
this lacquer covered box.

This beautiful lobed lacquer dish
of the Sung dynasty is one of the
few specimens of Sung lacquerware
that has survived.

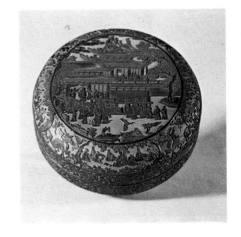

Lacquer covered box in two colours.
This lovely box which dates to the
15th century, is a magnificent
example of Ming craftsmanship.

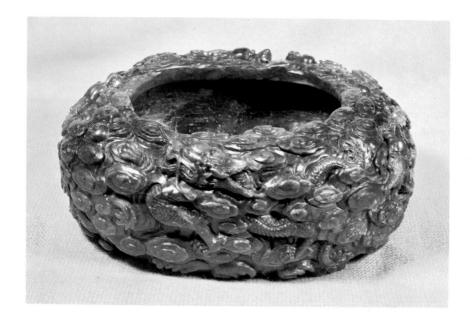

The golden age of jade is generally agreed to have been the Ch'ing dynasty. This is well illustrated by this finely carved Ch'ing 'Dragon Bowl' of the 18th century. During the Cultural Revolution, large numbers of later antiquities of the Ming and Ch'ing dynasties were collected for China's museums.

Jade has always been highly treasured in China, but never more so than in the Ch'ing dynasty. The Ch'ing Emperor Ch'ien Lung was fond of jade and commissioned many works. This carved jade vase was created in the 18th century during the 'Golden Age'.

during his stay in China. He was greatly taken with the town planning. He wrote "the lines (of the streets) are marked out uniformly and symmetrically, like a chessboard" a fact which modern excavations have confirmed.

Buildings of the Yuan dynasty have also been uncovered. Two fairly well preserved courtyards were found behind Yung Ho Kung and Hou Ying Fang, the foundations and the lower part of the walls were constructed of bricks and the floor cleverly made of smooth square bricks. Remains of lattice work doors were also found. A rare fragment of Yuan lacquerware was unearthed beneath the Hou Ying Fang building. Part of a lacquer plate, it has a central motif inlaid with mother-of-pearl. The design depicts the legendary female figure Ch'ang Ngo, escaping to the moon, and in the background to the design Kuang Han Kung, the "Palace of Cold Vastness in the Moon". Although fragmentary, this piece is most important as Yuan lacquerware is rare. Our knowledge of Yuan lacquer comes mainly from Chinese and Japanese documentary sources, which describe five groups of lacquer. They include plain red and black ware; the Ch'iang-chin process of engraved and gilded designs; mother-of-pearl inlay; guri-lacquer, or multi-coloured layers of lacquer deeply carved like a cameo, some on a yellow base; and finally carved lacquer. Few specimens of these types have been found.

Stoneware vase with floral decoration painted in brown under a white glaze, Sung dynasty (A.D.960–1280).

Another piece of Yuan lacquerware uncovered during the excavations at the Yung Ho Kung site was inscribed with the words, "For use in the inner mansion". A porcelain vase bearing the same inscription was found at the Hou Ying Fang site.

A large cache of porcelain was discovered in 1970, when the old city wall was revealed at Old Drum Tower Street. The porcelain, which was buried only eighteen inches beneath the ruins of a building was covered with an inverted basin. In all, sixteen vessels were recovered, all of which are of great importance, for a stratified find of Yuan porcelain is a rare occurrence They illustrate a cross section of Yuan porcelain types. There were nine vessels of underglaze blue decoration, including a beautiful bowl on a tray, and a phoenix-headed flask. The blue and white porcelain, newly developed in the Yuan period was to become very popular during the succeeding Ming dynasty. Two ying ch'ing celadon bowls are of interest as they were inscribed in the Phaspa script. The script, a Mongolian phonetic system was adopted for use in Yuan official documents in the 6th year of the reign of Chih Yuan, in 1269. It was developed by the linguist Phaspa who based it on the Tibetan script.

The dwellings of the ordinary people of the time, especially those on the lowest level of

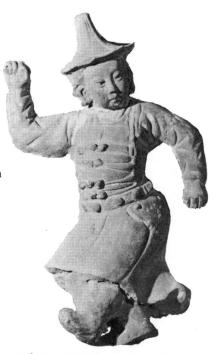

society, contrast with the well built mansions of the nobility. The remains of a small hut were unearthed at Middle School No. 106. When standing it must have been an extremely damp place with the floor being about eighteen inches lower than the doorway. The walls were of broken brick, there was a stove, a stone mortar, a brick bed, a *k'ang,* and pottery utensils that were extremely coarse and crude.

In the summer of 1969, work-men working on a site of the Arrow Tower at Hsi Chih Men uncovered the barbican entrance to Ho Yi Men, the "Gate of Harmony and Righteousness"

The defense work had an inscription above the entrance, written in ink, dating it to 1358. The barbican measured 72 feet high, with the entrance 32 feet long, 15 feet wide and 21 feet high. The massive structure had a most interesting feature, an archway made of brick, the first time the innovation had been used. There were three fortified rooms, and on the floor of the gate tower, cisterns from which water could be released through five openings, to combat fire in the event of an attack.

The excavations at Tatu amply illustrate the downfall of the Yuan dynasty. Conditions in the country had gradually deteriorated. Although in the beginning there was a healthy internal and international trade, this declined as internal conditions grew worse. The people were forced to pay heavy taxes and the peasants conscripted for forced labour, thus a feeling of unrest began to foster and the people revolted against the dynasty. Led by the popular leader Chu Yuan-chang, the Mongols were overthrown in a great rebellion of 1368. Uprisings had started sometime before this date, for we know from written records that Tatu was attacked by an insurgent peasant army in the 3rd moon of the 18th year of Chih Cheng, 1358. This was the year in which the barbican gate, Ho Yi Men was hastily constructed. The hurried burial of valuables such as the cache of nineteen pieces of

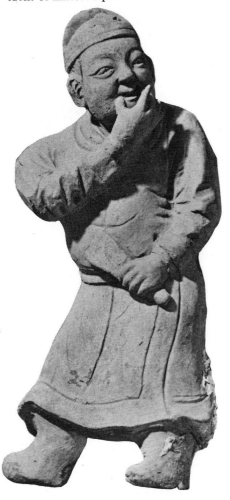

Left: *Pottery figure of a dancer unearthed at Chiaotso, Honan. Yuan dynasty (1271–1638).*

Right: *A pottery figure of an actor unearthed at Chiaotso, Honan. Yuan dynasty (1271–1638).*

porcelain also illustrates the unrest of this period.

Another find, dating to the period of the Yuan downfall, was unearthed by two peasants of the Changchuang People's Commune, of Tsaochuang in Shantung. They ploughed up a seal which belonged to Han Lin-erh, leader of the "Red Turban Army" a peasant force which rose in the rebellion of 1368. It is inscribed, "Commander of Ten Thousand Troops".

The great Ming dynasty restored native Chinese power and brought renewed self respect and purpose to the Chinese people. It lasted from 1368 - 1644, during which time China experienced a renaissance of the

Yuan dynasty (1271–1638) blue and white porcelain jar, painted with an underglazed design of a dragon and clouds. Found at Chintan, Kiangsu.

arts and literature. Ming admin-
istration was extremely efficient
with thousands of civil servants
and bureaucrats being employed.

After the years of what the
Chinese looked upon as foreign
domination, they revived Chinese
traditions and art forms by
looking backwards for inspiration.
It was the age of the scholar-
artists, the Wen Jen, and the
collector and connoisseur. In the
Confucian tradition, painting was
considered an essential pursuit of
men of letters.

Quite a number of paintings of
the Ming dynasty have survived and
are far more plentiful than those
of earlier periods. The art can best
be described as Baroque. Painting
during this period was essentially
the pursuit of the literati, and was
the respectable pursuit not only
of the scholar-administrator class,
but also of the great landowners.
It was this scholarly interest
coupled with the Baroque spirit
that was responsible for the
growing theoretical interest in art
and the production of numerous
treatise and art literature. These
have left their mark on Chinese
art criticism and appreciation even
to the present day.

The paintings of the literati,
the non-professionals, the Wen
Jen Hua (Painting of the Literati)
were identified with the Southern
School, carrying on the tradition
of the four great painters of the
Yuan period. One might say that
the arbitary division between the
Southern and Northern Schools

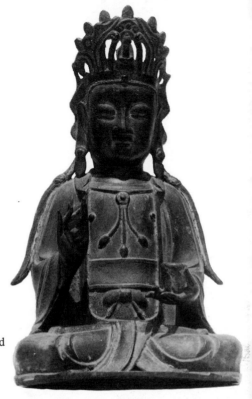

Ming dynasty (1368–1644) gilt bronze figure of a Bodhisattva.

was one of snobbery. The literati
considered painting one of the
true cultural pursuits and wished
to distinguish between their
paintings and those of the
professionals of the Northern
School. In actual fact it is often
difficult to distinguish between
the two schools. Painting was
considered the major art form of
the period, although crafts such as
porcelain, pottery and lacquer
rose to great heights.

By the Ming dynasty sculpture
had declined. During the Yuan
dynasty, Buddhism had received
a new impetus when it was made
the official religion. This was
reflected in the sculpture and

images made in Lamaistic forms, influenced by Tibetan and Nepalese types, a practice which continued into the Ming dynasty. Lamaistic icons were both sculptured in wood and stone and cast in bronze. Bronzes of the period are formal, sometimes to the extent of being rigid. The anatomy of the figures is usually full, draped in robes that are stiff and sculptural. The face is usually squarish, the nose rather wide, the eyes slit and sometimes the figures have a sublime smile.

Monumental sculpture was produced, but much of the vitality and spirit of the earlier periods had been lost. In fact a change had occurred, carvings were generally smaller, made of ivory or similar material, rather than stone or wood. Some jade was also carved.

One of group of blue and white porcelains of the Yuan dynasty found beneath the north city wall of Peking.

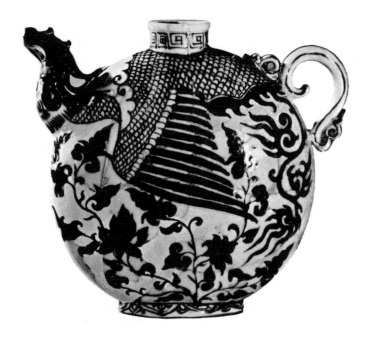

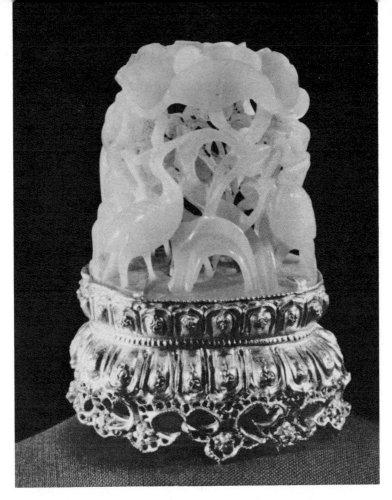

A white jade carving of egrets and lotus flowers on a gold base. From Nanking, Kiangsu. Ming dynasty (1368–1644).

An insight into the life and material culture of the period was given in 1970, when the tomb of Chu Tan, the Ming Prince of Lu, was unearthed at the foot of the Chiulung Mountain in Shantung.

In the winter of 1969 peasants of the Shangchai Production Brigade were building terraced fields on the southern slopes of Chiulang Mountain when they noticed a large mound of earth. This was duly reported to the local authorities in charge of antiquities and cultural relics, and after approval, an excavation was carried out by the Shantung Museum excavation team. The archaeologists believed the site to be the tomb of Chu Tan, which according to historical records and local folklore, was situated in the area.

135

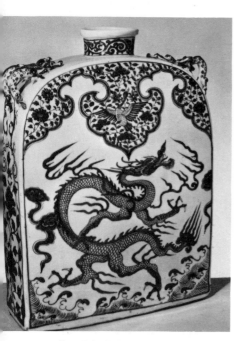

Porcelain flask painted with a dragon dragon design in underglaze blue. 14th century.

The entrance to the tomb and underground passage was discovered and work began. Excavation proved extremely difficult with falls of earth in the underground passage hampering excavators and making work extremely dangerous. Eventually help came from a nearby coal mine. Miners, hearing of the difficulties of the archaeologists, erected supports in the shaft so that work could proceed safely. Another problem was water, which was seeping into the underground chambers, making it impossible to remove the "gate-sealing-wall". Two pumps were brought to the site and gradually the water was lowered. The task of removing the "gate-sealing-wall" was still very great. The massive wall was constructed of huge bricks cemented together layer upon layer. Behind this was yet another wall.

The excavation proved to be a large scale operation and help was sought from the nearby commune and barracks. At length, the wall was lowered but they could not enter as a red lacquered gate barred their way. There was yet another problem. Originally there had been a massive stone weight at its top to keep the gate frame steady, but the frame had cracked and the stone had sunk, blocking the gate. There was great danger of the stone falling even further, positioned as it was, it also threatened the lower part of the structure. A number of ways of dealing with this massive obstacle were proposed but the only one which proved at all practical was also extremely dangerous, that was splitting the stone and breaking it up. After the delicate operation had been performed by two expert stonemasons, the archaeologists were at last able to open the gate and enter the tomb.

The tomb was like a vast underground treasure house. The underground water had helped preserve the contents by excluding air, and ensuring a constant low temperature. Precautions however, had to be taken in the removal of the contents. Everything had to be carefully washed and dried,

requiring expert skill. In this way all the objects were preserved to recover much of their former beauty.

Chu Tan's massive tomb consisted of two chambers and an underground passage over 70 feet long. The tomb had been hollowed out of the mountain and chambers built of large bricks. Both chambers were sealed by a stone gate lacquered in red. The outer wall, the chinkang wall, a "wall of guards", was over 26 feet high and the second "gate-sealing-wall" 10 feet thick. The floor of the tomb was some 85 feet beneath ground level. Chinese archaeologists have estimated that it took 800,000 working days to construct the tomb.

The first chamber contained an amazing model of the Prince's entourage, consisting of two carriages, three hundred and eighty human figures and twenty four models of horses. The figures form a procession led by soldiers armed with swords, lances, bludgeons, halberds and battle axes. They are followed by figures beating drums, playing the *Sheng*, a kind of mouth organ with pipes, and figures holding canopies and fans. They in turn are followed by the courtiers. Also in the antechamber was the Prince's grand seal, "Treasures of the Prince of Lu", symbolising his royal power.

Chu Tan's coffin and coffin case were in a remarkable state of

Lacquer tray with a design of a phoenix and blossoms. Ming dynasty (1368–1644).

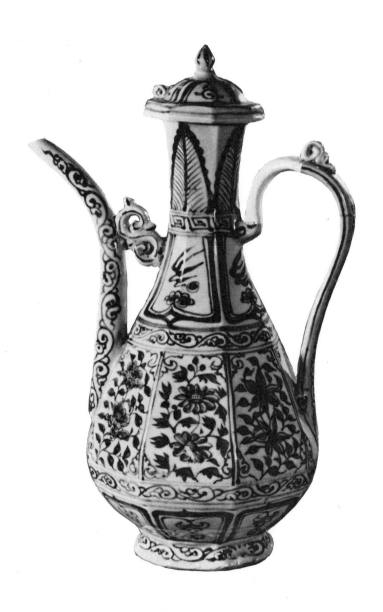

Porcelain octagonal ewer painted in underglaze blue with a floral design. Yuan dynasty (1271–1638). Found at Paoting, Hopei.

preservation, as were other perishable materials including his hats, crown, robes, books and paintings.

Over three hundred volumes of books were buried with the Prince. Printed in the Yuan dynasty (1271–1368) they are of immense interest and promise to add to our knowledge of the history of the period. There were also paintings and caligraphy of the Sung and Yuan dynasties, including a beautiful painting of butterflies and blossoming hibiscus, with a gold inscription in the caligraphy of the emperor Kao Tsung of the Southern Sung dynasty. In addition to the Prince's books and paintings, his writing materials, writing brushes, ink stone and writing paper were also buried with him.

Chu Tan was obviously well versed in the arts as well as being a collector and connoisseur. In addition to his antiquarian books and antique paintings buried with him, his antique zither also accompanied him to the next world. A two line inscription beneath the waist of the seven stringed instrument drew attention to the fact that it was made by Lei Wei of the Sung dynasty.

Of great interest was the lacquer furniture, square lacquer cases, and a lacquer case to hold the royal tablets. Both cases were painted in gold with designs of dragons. Lacquer is attributed to the Ming period nearly always on the grounds of style, design and workmanship, and only occasionally by inscriptions. Thus the

Porcelain dish decorated with polychrome design, unearthed at Peking. Ming dynasty (1368–1644).

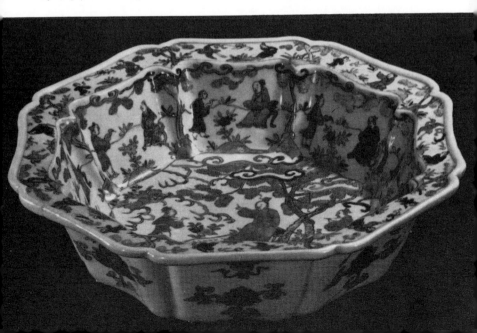

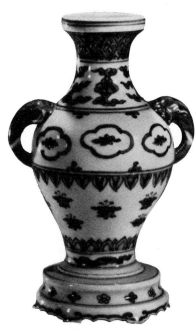

Porcelain vase decorated in underglaze blue. From Peking. Ming dynasty (1368–1644).

finding of lacquer which can be dated by its surroundings is most valuable.

All this opulence and material wealth went to accompany a boy of nineteen to the nether world, for that was all he was when he died, the same age as Tutankhamun. Chu Tan was the tenth son of Chu Yuan-chang, the first emperor of the Ming dynasty. He was born in 1370, two years after his father had led the uprising against the Yuan Mongols and established his own dynasty.

Chu Tan was made Prince of Lu at the age of two months, but did not take up residence at Yenchow, Shantung, the seat of his principality until he was fifteen. He died in the twenty second year of his father's reign, in 1389.

Like the other dynasties before it, the power of the Ming gradually declined, the government corrupted by bribary and internal feuds. There were a number of uprisings, but the coup de grâce was administered by the Manchus who invaded and conquered China, setting up their own dynasty the Ching dynasty. The country was not wholly conquered, however, until the rein of the second Manchu emperor, K'ang Hsi (1662–1722). The Ching emperors, patronised the arts, especially Ch'ien Lung who loved jade and lacquer. During During the Ching dynasty numerous objects of great beauty were made, many of which have been collected from various parts of China during the Cultural Revolution and placed in China's museums.

Archaeology in China is at a most exciting stage. The new discoveries of recent years both of archaeological sites and objects, from the earliest times to the Ching dynasty, promise to be just the beginning of an era of new knowledge, knowledge which is vital to our understanding of Chinese art and archaeology. Archaeology in China today, then, is providing evidence of the material culture of all periods, the later arts joining with those of earlier periods which together make up the treasures of China.

CHRONOLOGY

Neolithic Period	c. 4000 – 1800 B.C.
Shang Dynasty	1523 – 1027 B.C.
Chou Dynasty	1027 – 221 B.C.
Spring and Autumn Period	770 – 475 B.C.
Warring States Period	481 – 221 B.C.
Ch'in Dynasty	221 – 206 B.C.
Han Dynasty	206 B.C. – A.D. 220
Western Han	206 B.C. – A.D. 24
Eastern Han	A.D. 25 – 220
Three Kingdoms	A.D. 220 – 280
Six Dynasties Period	A.D. 280 – 589
Northern Wei	A.D. 385 – 535
Eastern Wei	A.D. 535 – 550
Western Wei	A.D. 535 – 557
Northern Ch'i	A.D. 550 – 577
Northern Chou	A.D. 557 – 581
Liu Sung (South)	A.D. 420 – 478
Southern Ch'i	A.D. 479 – 501
Liang Dynasty	A.D. 502 – 557
Ch'en Dynasty	A.D. 557 – 588
Sui Dynasty	A.D. 589 – 618
T'ang Dynasty	A.D. 618 – 907
Five Dynasties	A.D. 907 – 959
Sung Dynasty	A.D. 960 – 1280
Liao Dynasty	A.D. 916 – 1125
Chin Dynasty	A.D. 1122 – 1234
Yuan Dynasty	A.D. 1280 – 1368
Ming Dynasty	A.D. 1368 – 1643
Ch'ing Dynasty	A.D. 1644 – 1912

INDEX

Acknowledgments *The publishers gratefully acknowledge the following for permission to reproduce illustrations: Various agencies of the People's Republic of China; The British Museum; The Victoria & Albert Museum, London: The Smithsonian Institution, Free Gallery of Art, Washington D.C.; The Cleveland Museum of Art; Sydney L. Moss Ltd., London; John Sparks Ltd., London; S. Marchant, London; and the author.*